Mr C J Plaw
"Beechcroft"
4 Davidson Close
Thorpe-St-Andrew
Norwich
Norfolk
NR7 0XP

18th Century Art

Jean-Honoré Fragonard
Grasse 1732-Paris 1806
Fantasy Figure, called *Inspiration*
Oil on canvas 2′7″ × 2′2″
Paris, Louvre

18th Century Art

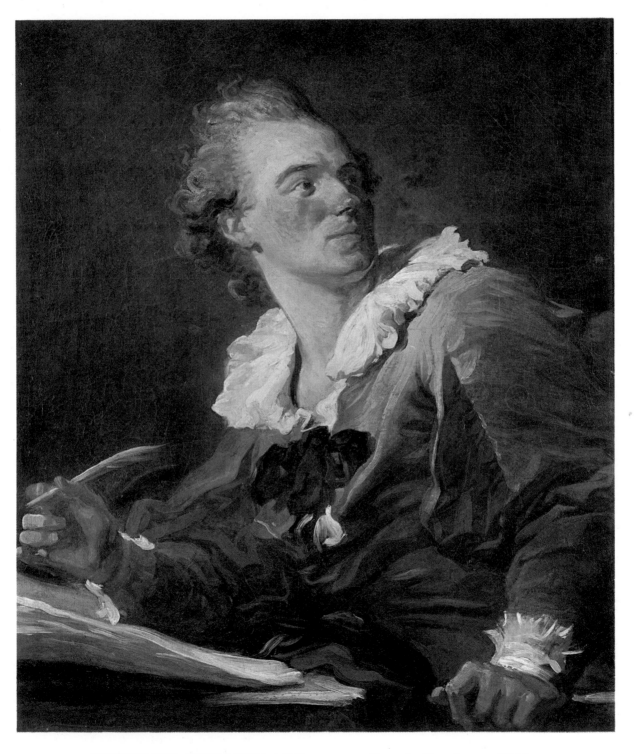

PEEBLES ART LIBRARY **Sandy Lesberg, Editor**

First published 1974
by
Peebles Press International
U.S.: 140 Riverside Drive, New York, N.Y. 10024
U.K.: 12 Thayer Street, London, W1M 5LD

ISBN 0-85690-030-3

The illustrations were provided by André Held, Lausanne,
except:
Scala, Florence: pages 22, 25, 26.
Courtauld Institute, London: pages 38, 40 (lower), 45, 48.
R. B. Fleming, London: pages 31, 36.
Rijksmuseum, Amsterdam: page 29.
Brompton Studio, London: page 42.
Giraudon, Paris: page 47.

Distributed by
Walden Books, Resale Division in the
U.S. and Canada.
WHS Distributors in the U.K., Ireland,
Australia, New Zealand and South Africa.

Printed and Bound in Great Britain

Introduction

A character of great unity may rightly be attributed to the culture of the 18th century, but in that case it must also be recognised as having a strong element of complexity.

The 18th century lends itself well to the title of " Elegant Century", or " Century of Enlightenment", one of epicurean behaviour and rationalist philosophy. It is also known as the " French Century", although it should be emphasised that this title is not of French invention but comes from across the mountains and the Rhine.

Historically, the century begins and ends with two events which, although emanating from France, are of European importance: the hegemony of Louis XIV and the imperialism of Napoleon. In the years between, although they are studded with political or economic defeats and setbacks, France maintains her place at the head of a Europe which spontaneously accepts the pre-eminence of her language, her literature and her art and adopts the etiquette of her court for its social usages.

It is taken for granted that foreign sovereigns go to the studios of French artists for their portraits, or to buy paintings to adorn the walls of distant palaces. In the same way French artists, or those trained in France, make triumphant journeys throughout Europe, staying to carry out highly-paid commissions or to found academies and art factories modelled on those of Paris. Thus is to become established the type of royal portrait painted by Rigaud, the mythological portrait perfected by Nattier, the worldly type of Van Loo, Tocqué and Perronneau; the same applies to genre paintings such as Watteau's Fêtes galantes *which his successors, in more or less worthy manner, triumphantly paint on overmantels, illustrating sentimental or licentious scenes from mythology ... or the Bible.*

" But was that the whole of European art? Did the powerful wave of French art submerge all national specialties and traditions?" We pose the question as did Louis Réau, principal architect of the " defence and illustration" of a French Europe, and we accept his answer: " Art as elaborated at Versailles and in Paris had an all-powerful influence on court and society art, which is international, but had no effect on religious and popular art." It must also be remembered that reservations about French expansion are manifest across the Channel and the Alps: in England because of a fierce Franco-British national rivalry and in Italy from " the proud consciousness of 18th-century Italians of a national school whose glory stems not only from its past but from the living and is made illustrious with great names".

In fact it is a Venetian, Tiepolo, who dominates the important sector of decorative painting, a derivation from and organic complement to the Baroque architecture of palaces and sanctuaries, while fresco, after the death of Louis XIV, is hardly used in France. The superb ceiling of the Hercules Salon at Versailles and some of the other works of François Lemoine and those who emulated him are only exceptions to the general rule represented by Boucher. Boucher's genre painting is better suited to the new style of interior architecture which favours blank ceilings and leaves to the decorative painter only overmantels above doors or panels. As for churches, France builds hardly any.

The situation is different in Germany and Austria, recovering after the Thirty Years War and the Turkish invasion. Churches and monasteries are rebuilt in thanksgiving. Vast abbeys, libraries, refectories, bishops' palaces and " imperial apartments" offer a rich field to the Italian fresco painters who before long are joined by native artists trained in the academies of Augsburg or Vienna.

The art of displaying the virtuosity of the brush over large but capriciously-divided surfaces calls for a real science in which the basic ideas of ceiling perspective, laid down in books by Andrea Pozzo and Paulus Decker, are combined with theological concepts or the commonplace ideas of Cesare Ripa's Iconology (that "Artists' Bible" which drew the condemnation of Winckelmann and which combines pagan mythology with Christian allegory).

Here, indeed, is an important aspect of 18th-century painting which deliberately stands aloof from a French Europe and the "Century of Enlightenment"!

In the same way, the Italians must be acknowledged as leaders in another form of painting: the urban panorama. The travels of the two Venetian "Vedutisti", Canaletto and Bellotto, throughout Europe produce a series of particularly vivid pictures of London, Vienna, Dresden and Warsaw.

If today we are to discover the "masters of reality of the 16th century", predecessors of those of the 17th century who held sway for thirty years, tomorrow we may do as much for the 18th century and find, near or far from the great Chardin and in France or elsewhere, a whole crop of lesser masters devoted to naturalism. The portrait abandons all pomp and becomes intimate. The landscape swings away from the Roman countryside and the precepts of Claude Lorrain towards opposite ideas which have no pretensions to a monopoly of beauty; like Ruisdael and other Dutch painters of the 17th century, the artist seeks to delve directly into nature. Finally, genre painting, not only that of Chardin, shows scenes of daily life far from the sophistication of the boudoir or the prowesses of the bedchamber.

Nor must the "Caravaggists" of the 18th century be forgotten, those isolated "tenebrists" who dot the "Century of Enlightenment" and with whom is joined, albeit incidentally, the great David with his Marat Assassiné (Murder of Marat). By the same token international Mannerism, which the historians say disappeared about 1620, shows some curious resurgence in the 18th century as with Magnasco or Fuseli.

Another example of the complexity of the 18th century is found in the second half in the sudden and total change in aesthetic conception which puts an end to the reign of the Baroque, by now 200 years old or very nearly, and installs neo-classicism, which develops in imitation of an antiquity brought to life by archaeological discoveries. This revolution in taste has its origin in Rome, cosmopolitan melting-pot of intellectuals and artists from all over Europe.

However, the classical inclinations of the French spirit, which consist of a feeling of keeping within bounds, exist outside of imitation of the ancients. They are to be found as much in the 13th century, golden age of Gothic art (was not Amiens Cathedral called the "French Parthenon"?), as in the works of Delacroix, head of the Romantic school. As for the 18th century, it is to be noted in the Régence and Louis XV styles, called "rocaille" (rococo), creations that are free but in which capriciousness is kept in check, and which contrast with the frenzied exuberances of the Rococo of Italo-German Baroque, in their last phases.

It is these contrasts, this variety and these metamorphoses which make for the charm and show the richness of painting of the European 18th century.

Boris Lossky
Curator of the Museums of Tours,
Amboise and Richelieu

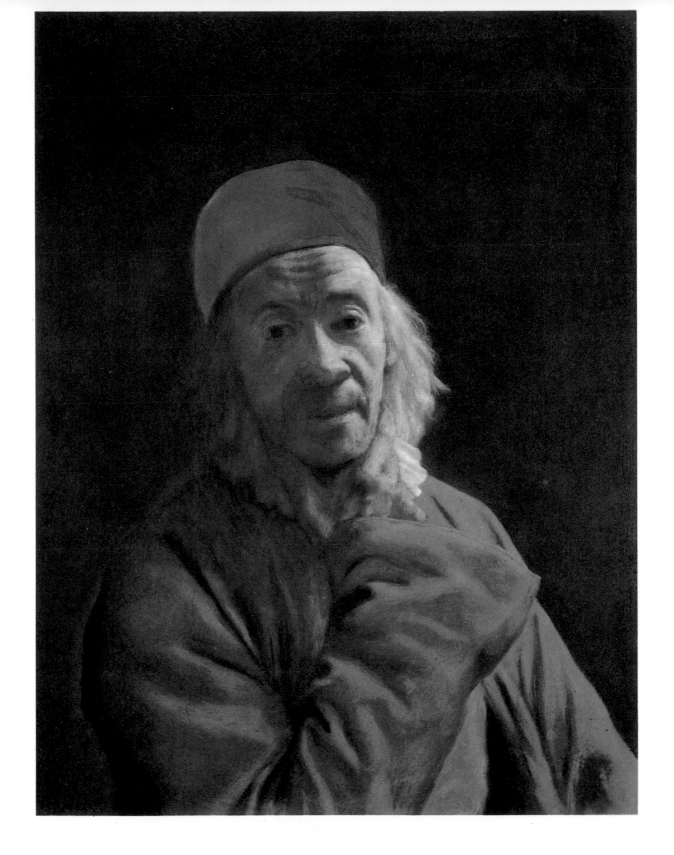

Jean-Etienne Liotard
Geneva 1702-89
Portrait of the Artist as an Old Man
Geneva, Museum of Art and History

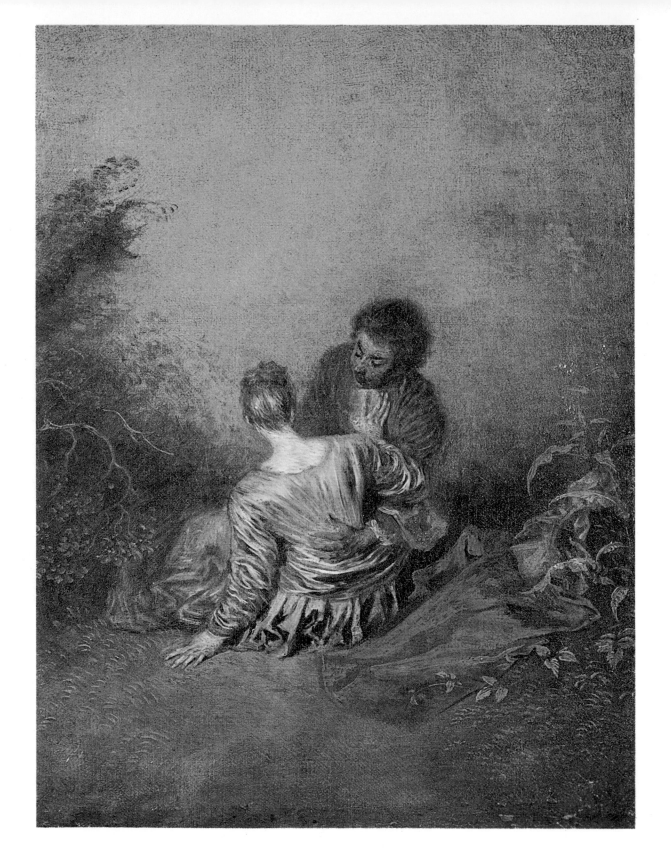

Antoine Watteau
The Faux Pas (sketch)
Oil on canvas 1′8″ × 1′4″
Paris, Louvre

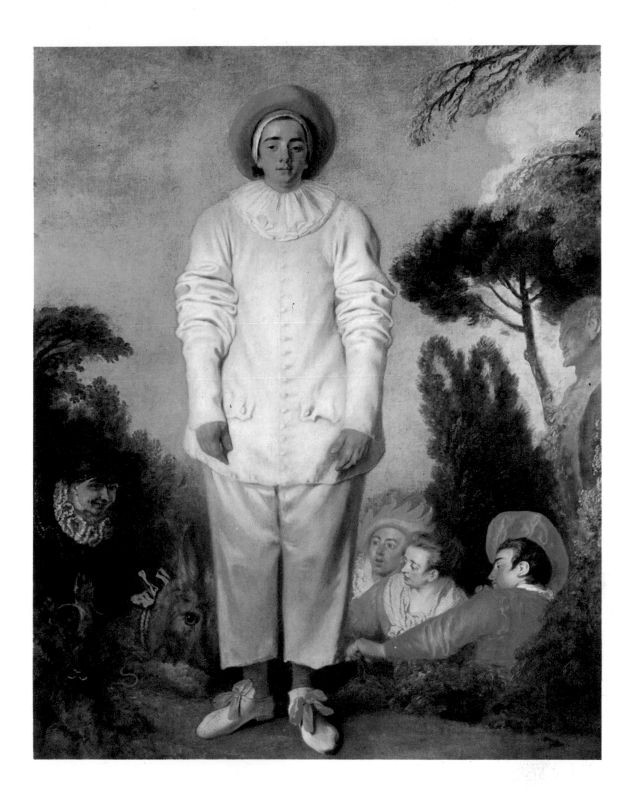

Antoine Watteau
Valenciennes 1684-Nogent-sur-Marne 1721
Gilles (Pierrot in The Commedia dell'Arte)
Oil on canvas 6′0″ × 5′0″
Paris, Louvre

Hyacinthe Rigaud
Perpignan 1659-Paris 1743
Marie Serre, Mother of the Artist, c. 1695
Paris, Louvre

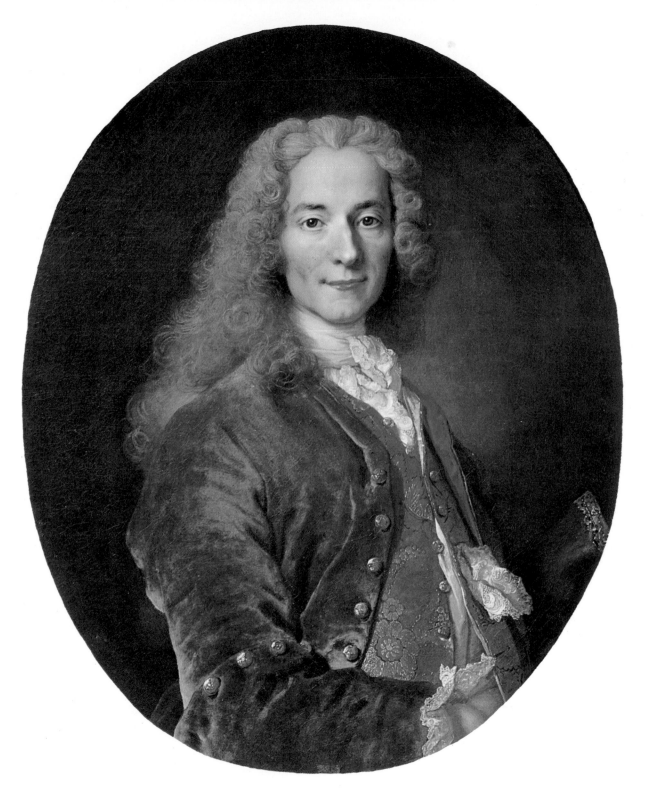

Nicolas de Largillière
Paris 1656-1746
Portrait of Voltaire
Versailles Museum

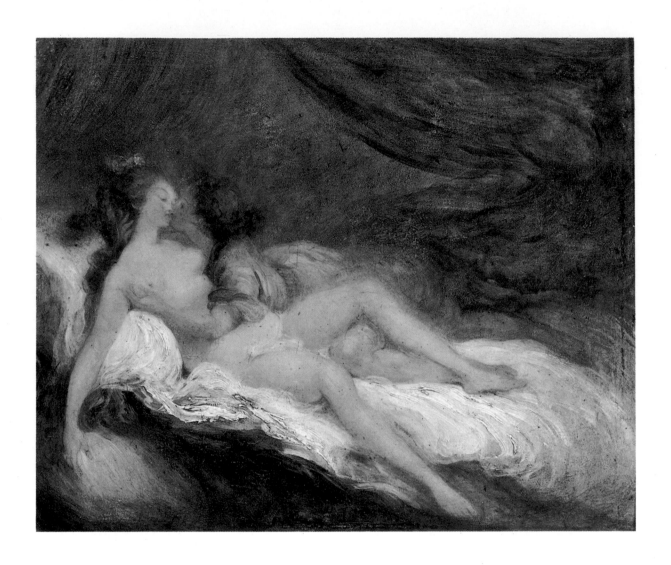

Jean-Honoré Fragonard
The Two Lovers
Oil on canvas 1′11″ × 1′6″
Sion, Leopold Rey Collection

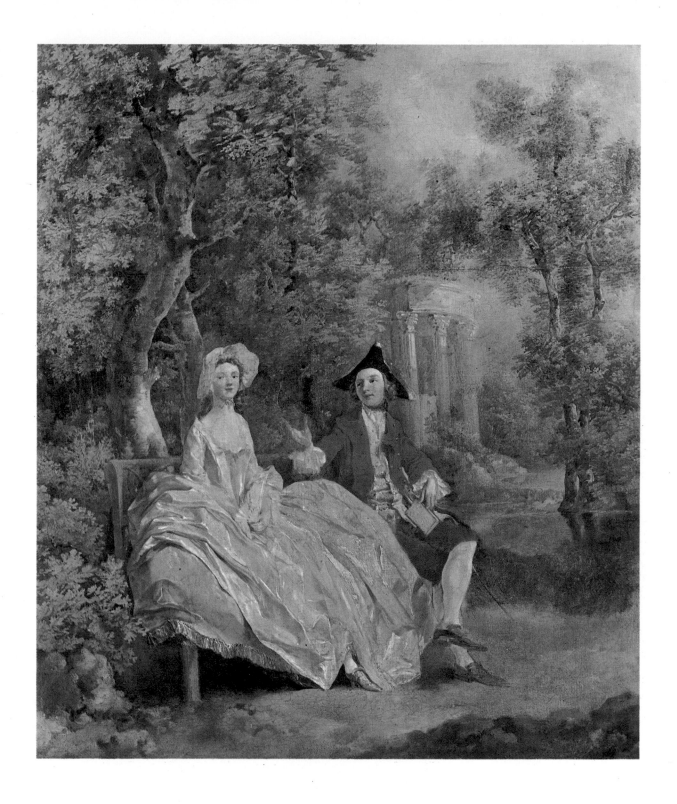

Thomas Gainsborough
Sudbury 1727-London 1788
Conversation in a Park
Paris, Louvre

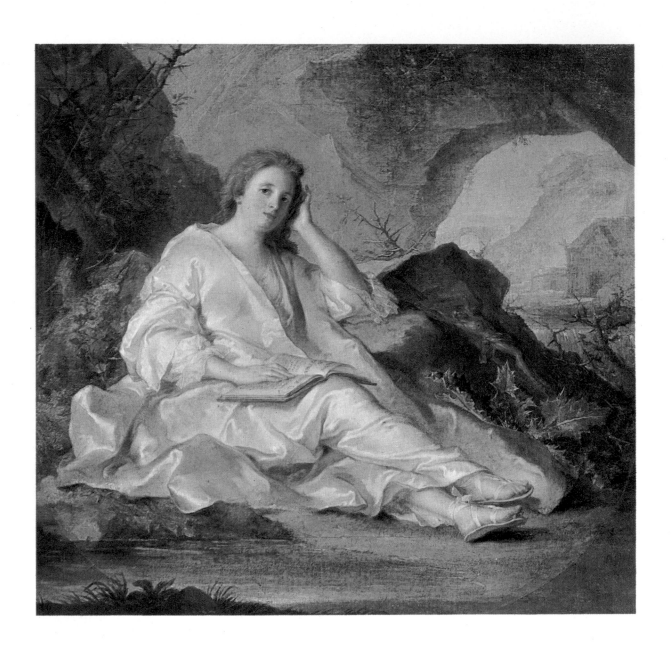

Jean-Marc Nattier
Paris 1685-1766
Penitent in the Desert
Oil on canvas 2′4″ × 2′6″
Paris, Louvre

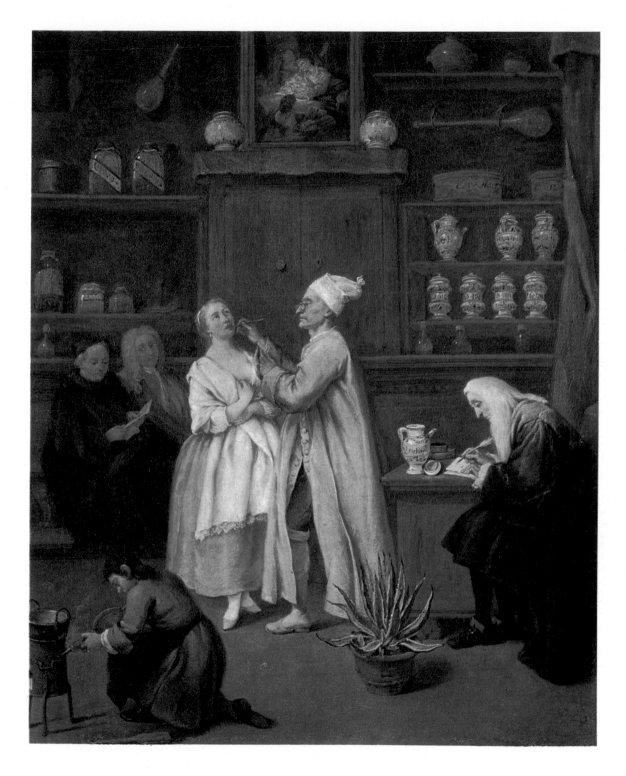

Pietro Longhi
Venice 1702-85
The Dentist
Oil on canvas 2′0″ × 1′7″
Venice, Academy

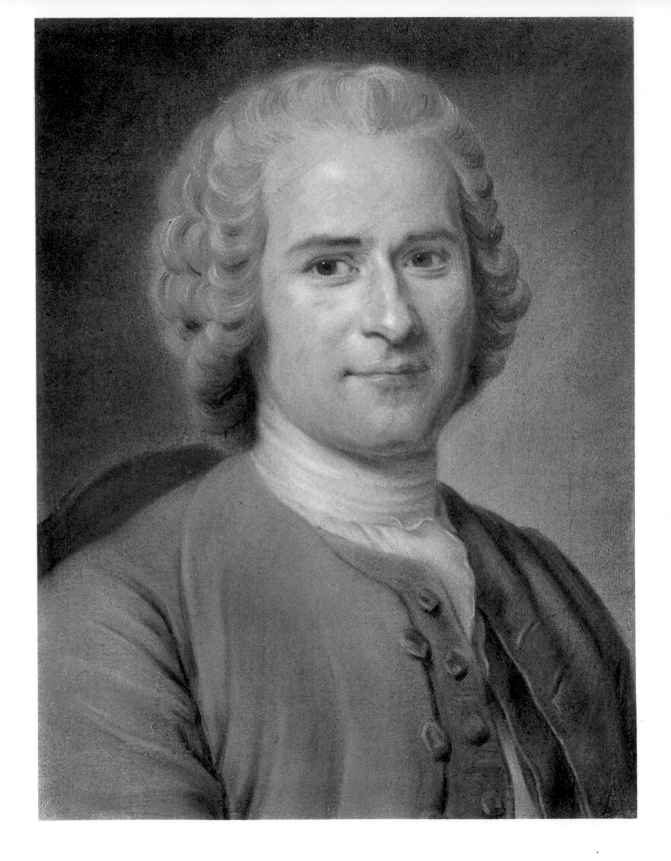

Maurice Quentin de La Tour
Saint-Quentin 1704-88
Portrait of Jean-Jacques Rousseau
Pastel 1′6″ × 1′3″
Geneva, Museum of Art and History

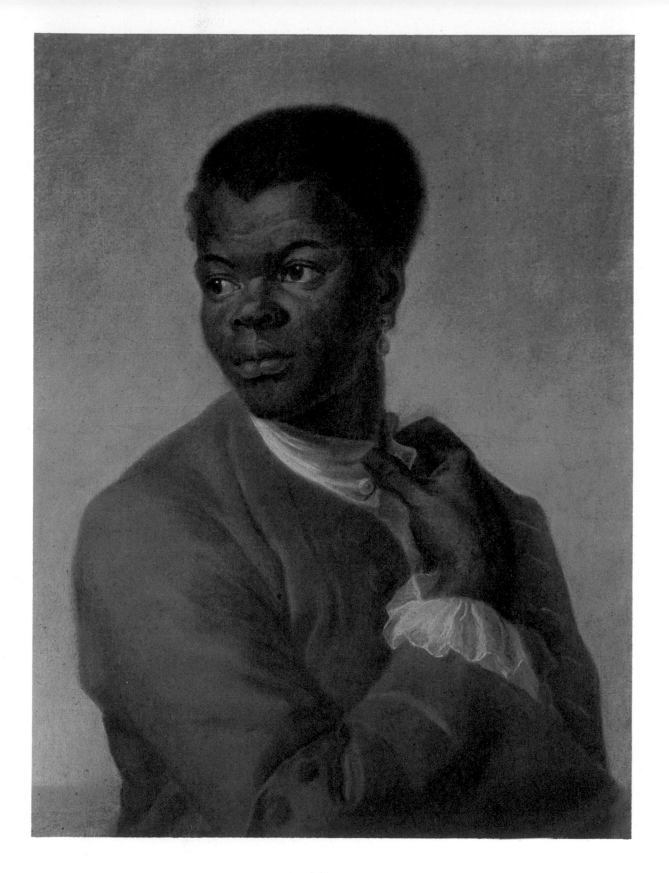

Maurice Quentin de La Tour
The Negro, 1741
Pastel 2′2″ × 1′8″
Geneva, Museum of Art and History

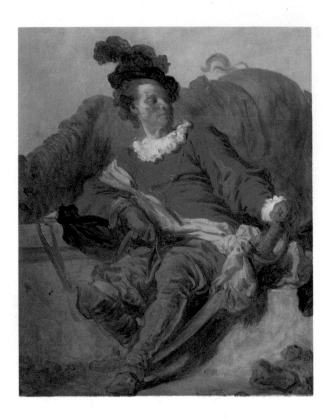

Jean-Honoré Fragonard
The Abbé St Non
Oil on canvas 3′1″ × 2′5″
Barcelona, Museum of Modern Art

Louis-Michel Van Loo
Toulon 1707-Paris 1771
Portrait of Diderot, 1767
Oil on canvas 2′8″ × 2′2″
Paris, Louvre

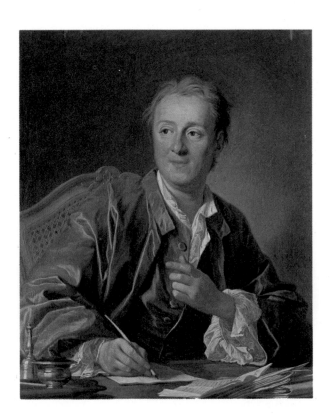

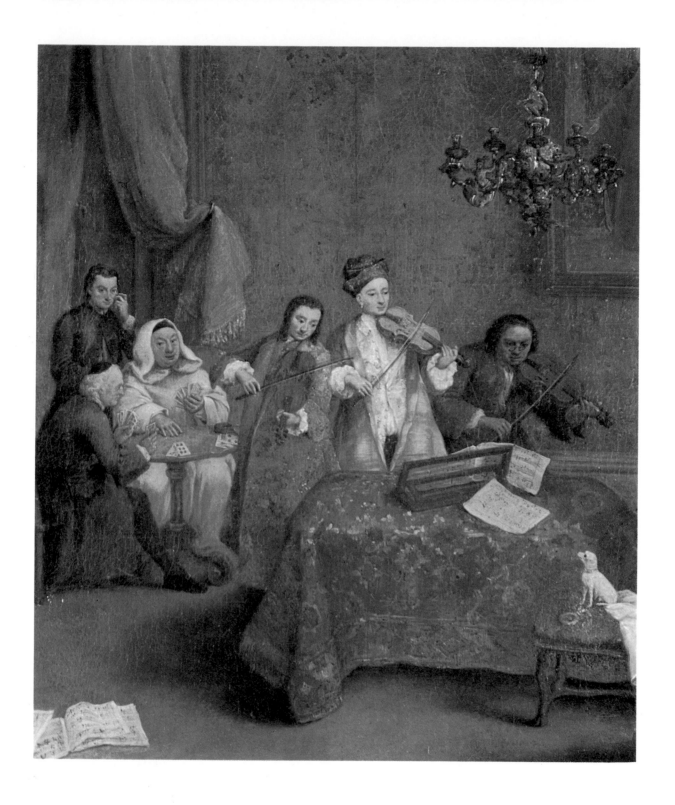

Pietro Longhi
The Concert, 1741
Oil on canvas 2′0″ × 1′7″
Venice, Academy

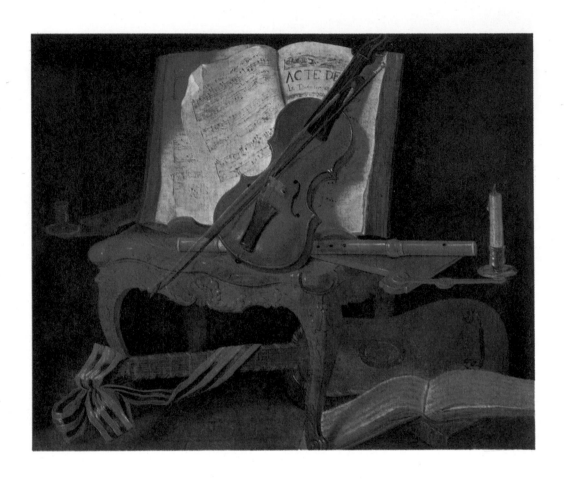

Jean-Baptiste Oudry
Paris 1686-Beauvais 1755
Still-life with Violin
Paris, Louvre

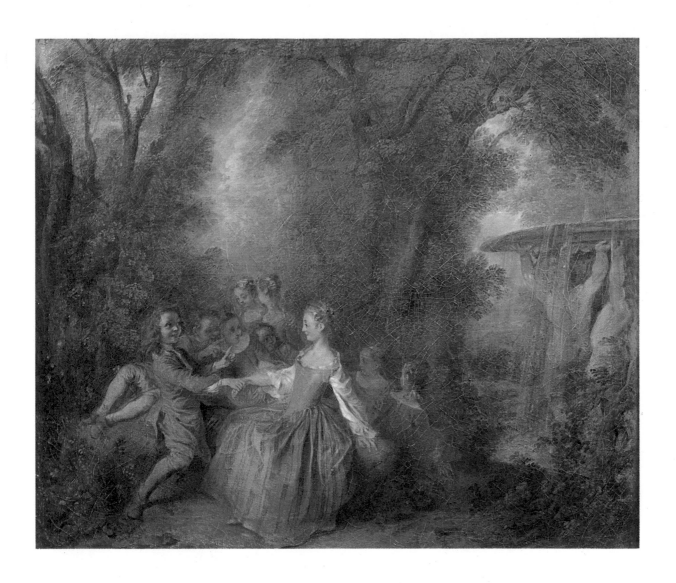

Nicolas Lancret
Paris 1690-1743
The Game of Pied-de-bœuf, *c*. 1738
Oil on canvas 1'5" × 1'6"
Berlin, New Palace

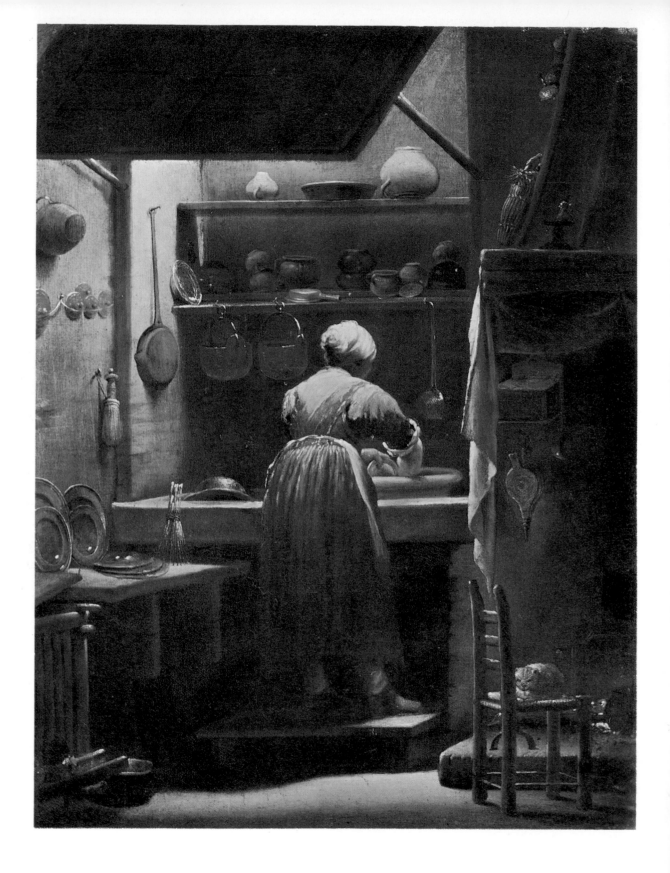

Giuseppe Maria Crespi
Bologna 1665-1747
Woman Washing Dishes
Florence, Cantini Collection

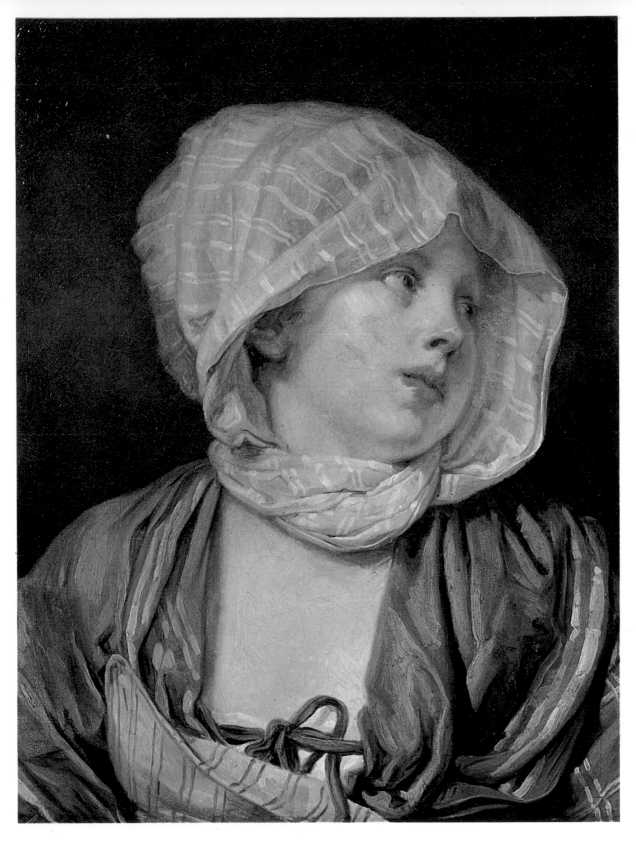

Jean-Baptiste Greuze
Tournais 1725-Paris 1805
Portrait of a Little Girl
Oil on canvas 1′7″ × 1′3″
Rome, National Gallery of Ancient Art,
Barberini Palace

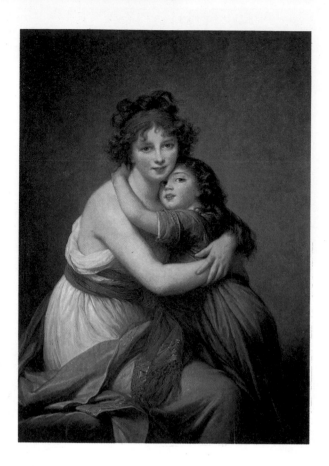

Elisabeth-Louise Vigée-Lebrun
Paris 1755-1842
*Portrait of Madame Vigée-Lebrun
and her Daughter. c.* 1789
Oil on wood 4'0" × 2'11", Paris, Louvre

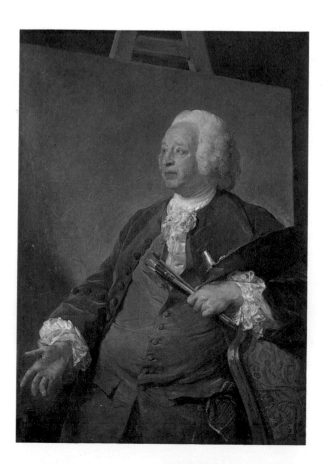

Jean-Baptiste Perronneau
Paris 1715-Amsterdam 1783
Portrait of Jean-Baptiste Oudry
Oil on canvas 4'3" × 3'3"
Paris, Louvre

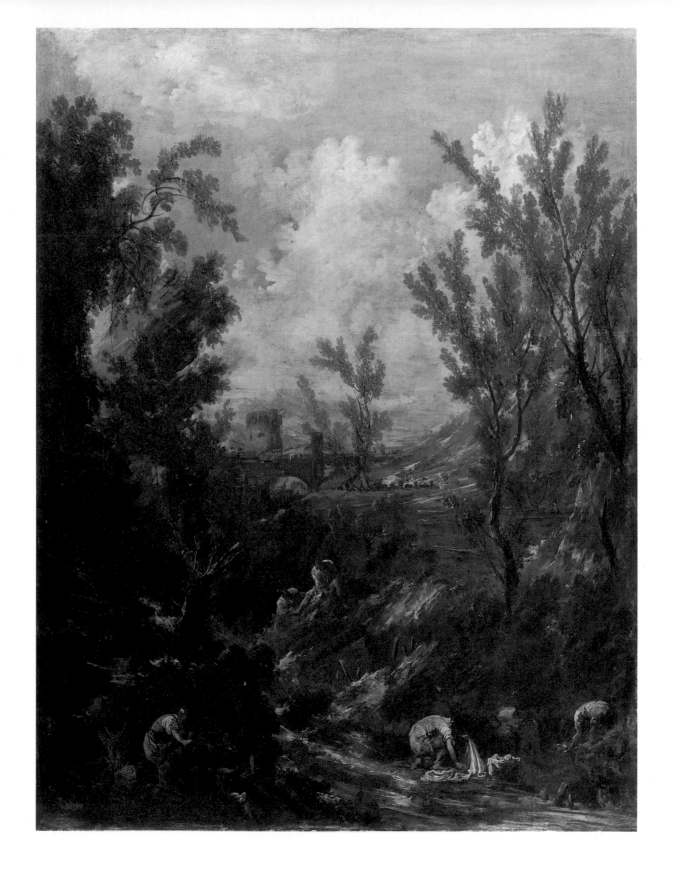

Alessandro Magnasco
Genoa 1667-1749
Landscape
Naples, Capodimonte

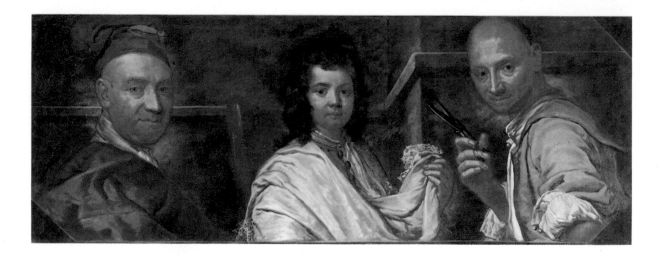

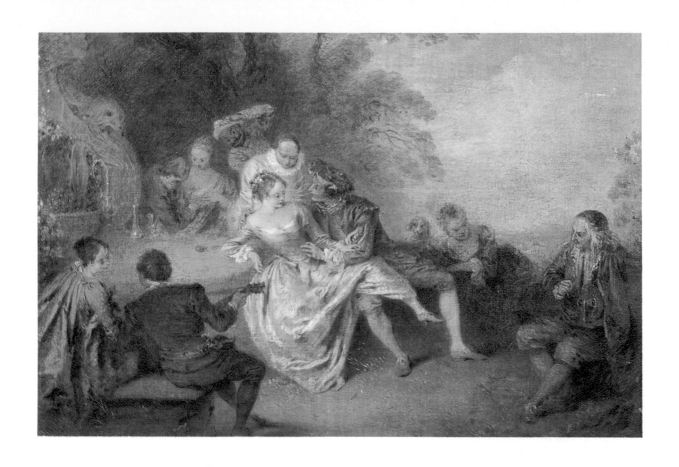

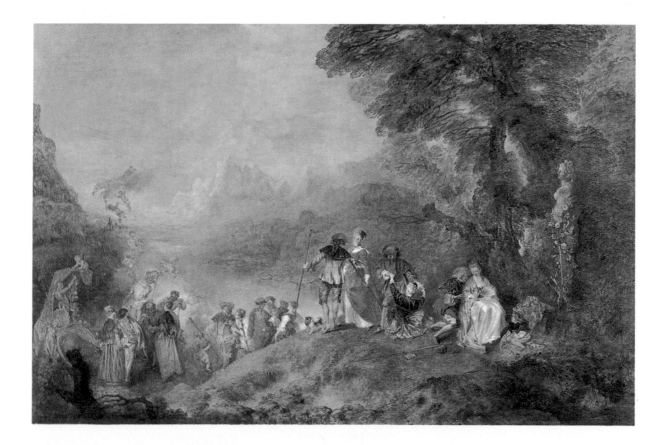

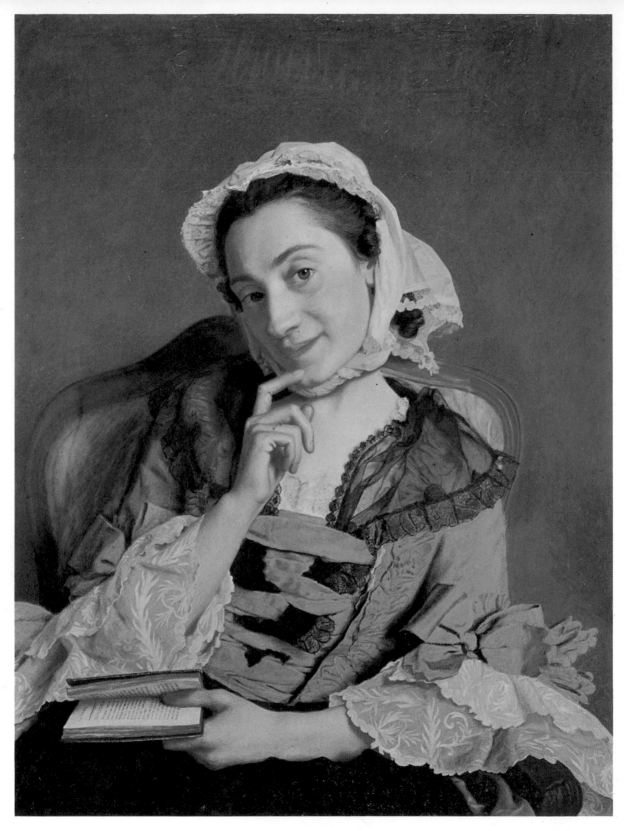

Jean-Etienne Liotard
Portrait of Madame d' Epinay
c. 1759
Pastel 2′3″ × 1′9″
Geneva, Museum of Art and History

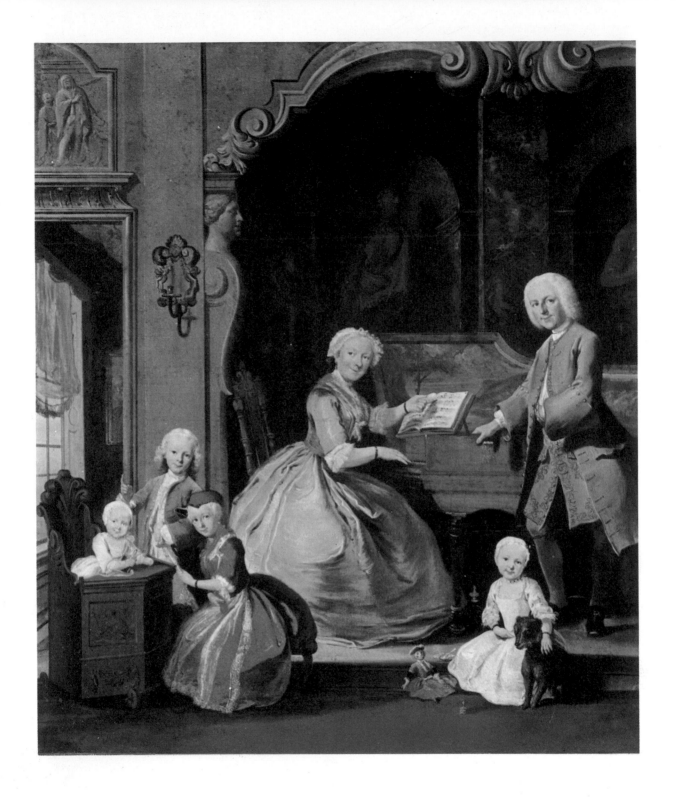

Cornelis Troost
Amsterdam 1697-1750
Family in an Interior
Oil on canvas 3′1″ × 2′8″
Amsterdam, Rijksmuseum

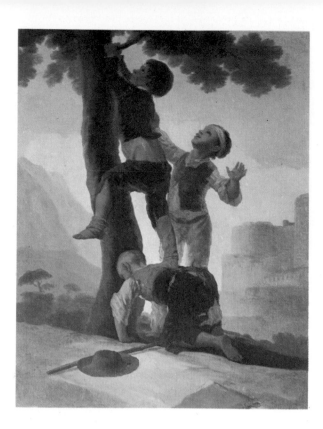

Francisco José de Goya y Lucientes
Fuentodos (Saragosa) 1746-Bordeaux 1828
Boys Climbing a Tree, 1791-2
Cartoon for a Tapestry
Madrid, Prado

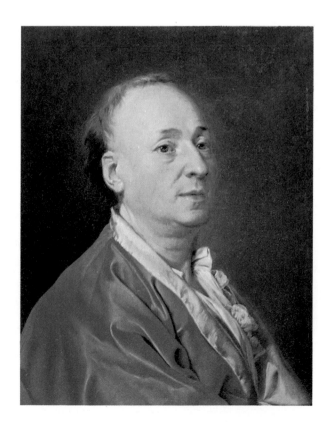

Dimitri Gregoriovich Levitzky
Kiev 1735-St Petersburg 1822
Portrait of Diderot
Oil on canvas 1′11″ × 1′7″
Geneva, Museum of Art and History

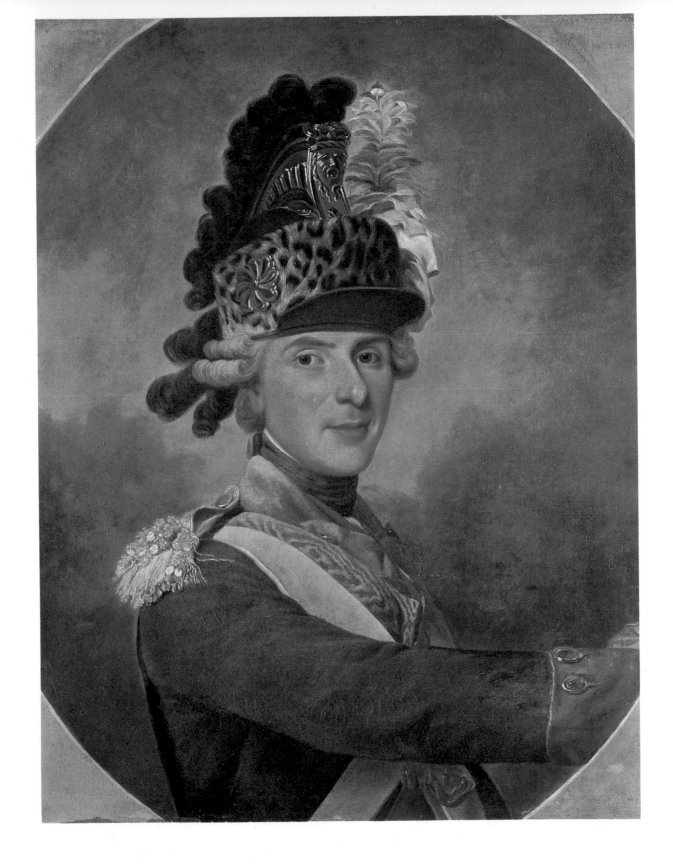

Alexander Roslin
Malmoe 1718-Paris 1793
The Dauphin, Son of Louis XV
London, National Gallery

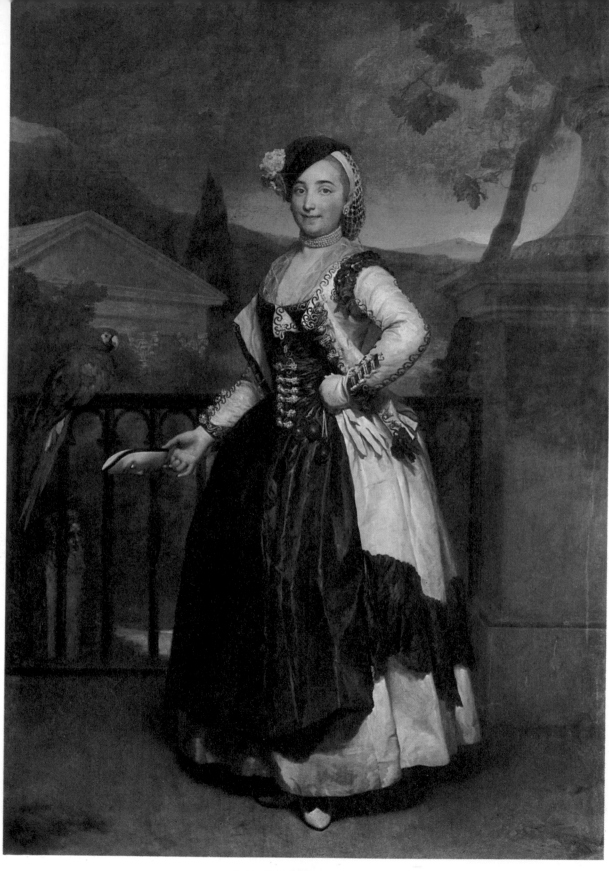

Anton Rafael Mengs
Aussig 1728-Rome 1779
The Marquise de Llano
Oil on canvas 6'8" × 5'1"
Madrid, San Fernando Academy

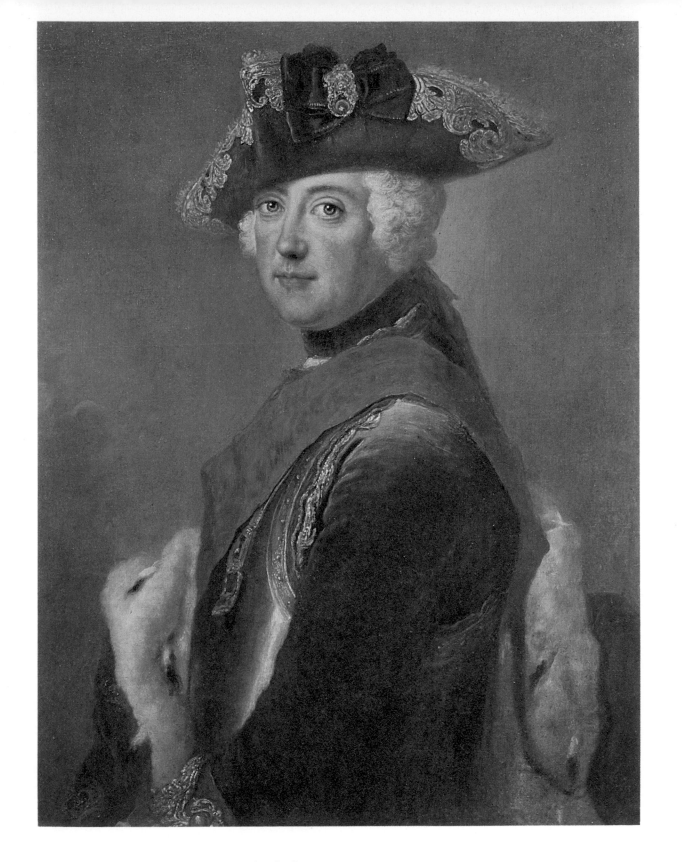

Antoine Pesne
Paris 1683-Berlin 1757
Portrait of Frederick II, King of Prussia
c. 1739-40
Oil on canvas 2'7" × 2'0"
Paris, Furstenburg Collection

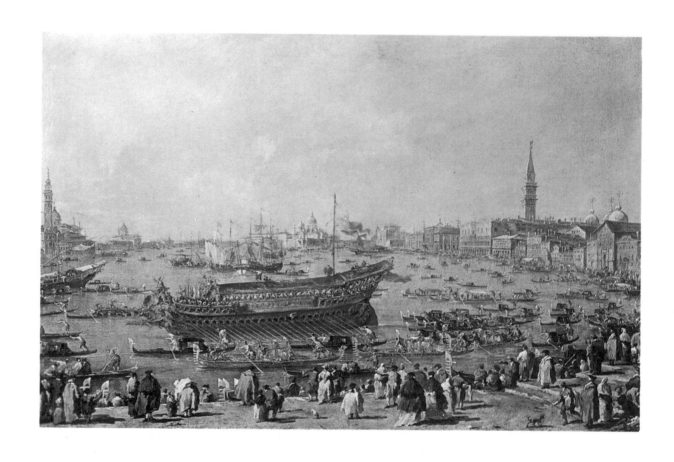

Francesco Guardi
Venice 1712-93
Departure of the " Bucentaur"
for the Ascension Day Ceremony
Oil on canvas 2′2″ × 3′3″
Paris, Louvre

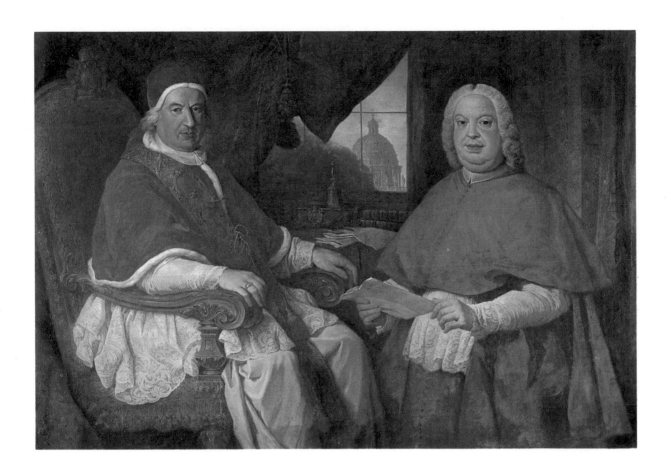

Giovanni Paolo Panini
Piacenza 1691-Rome 1765
Benedict XIV Lambertini and Cardinal Silvio
Valenti Gonzaga
Oil on canvas 4′0″ × 5′10″
Rome, Rome Museum, Braschi Palace

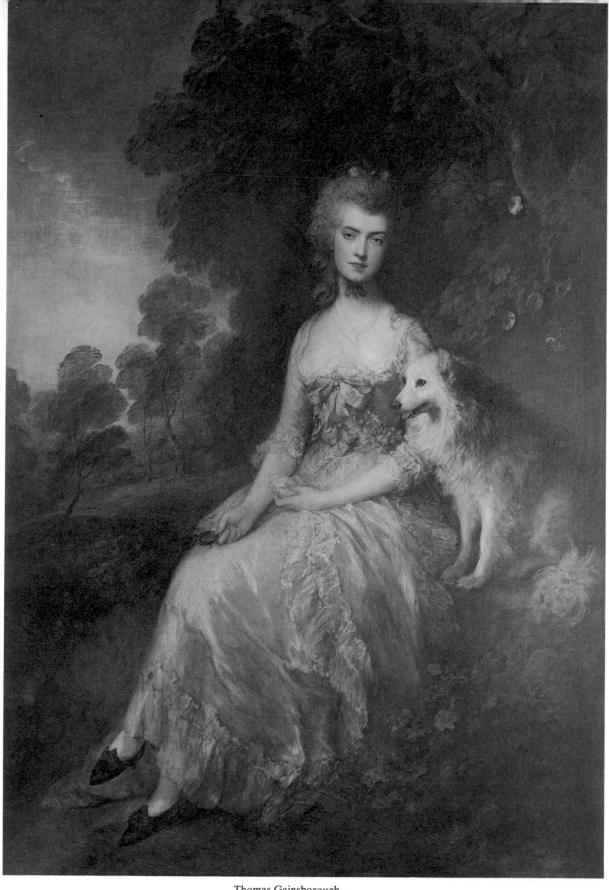

Thomas Gainsborough
Sudbury 1724 London 1788
Perdita
London, Wallace Collection

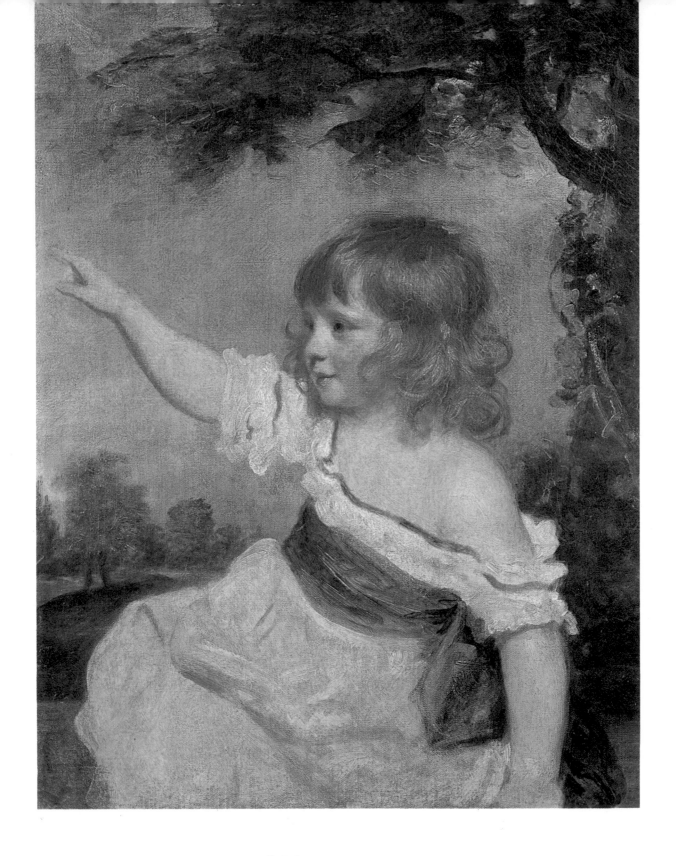

Sir Joshua Reynolds
Plympton 1723-London 1792
Portrait of Master Hare; 1788
Oil on canvas 2′6″ × 2′0″
Paris, Louvre

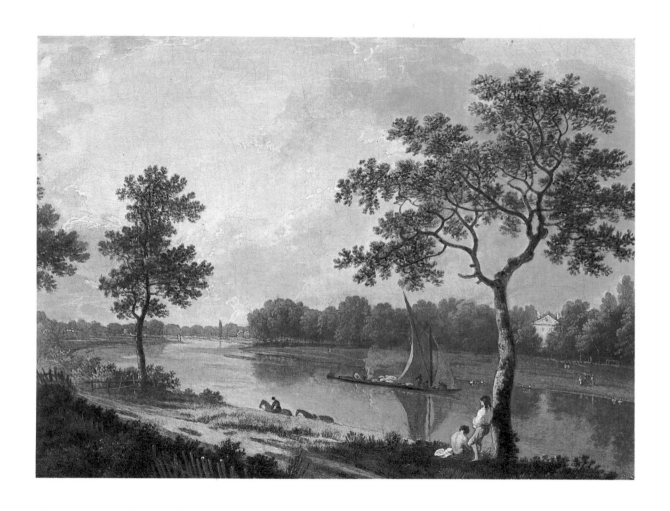

Richard Wilson
1714-82
The Thames at Twickenham
London, Tate Gallery

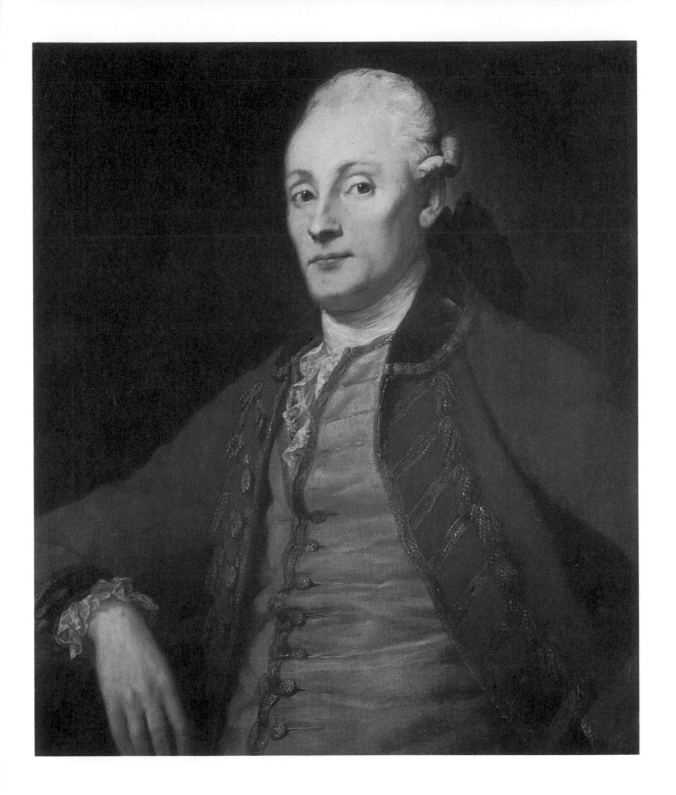

Anton Graff
Winterthur 1736-Dresden 1813
Portrait of Chambellan von Beust, 1780
Oil on canvas 2′6″ × 2′0″
Winterthur, Reinhart Collection

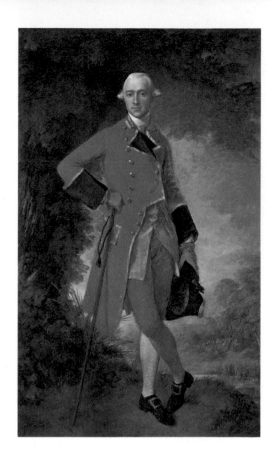

Thomas Gainsborough
Portrait of Lt-Col Edmond Nugent
Oil on canvas 7′9″ × 5′1″
Lugano, Thyssen Collection

George Romney
Dalton-in-Furness 1734-
Kendal 1802
Lady Hamilton as Circé
London, National Gallery

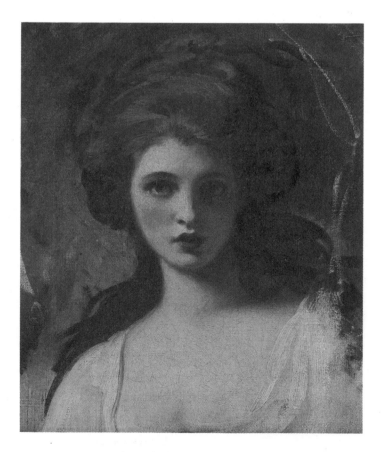

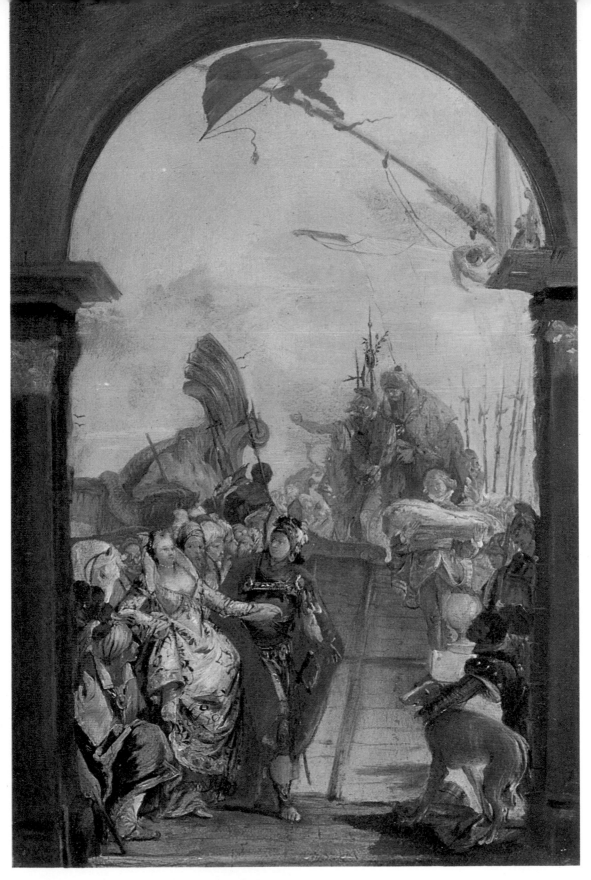

Giambattista Tiepolo
Venice 1696-Madrid 1770
The Embarkation
Sketch for fresco in the Labia Palace, Venice
Strasbourg Museum

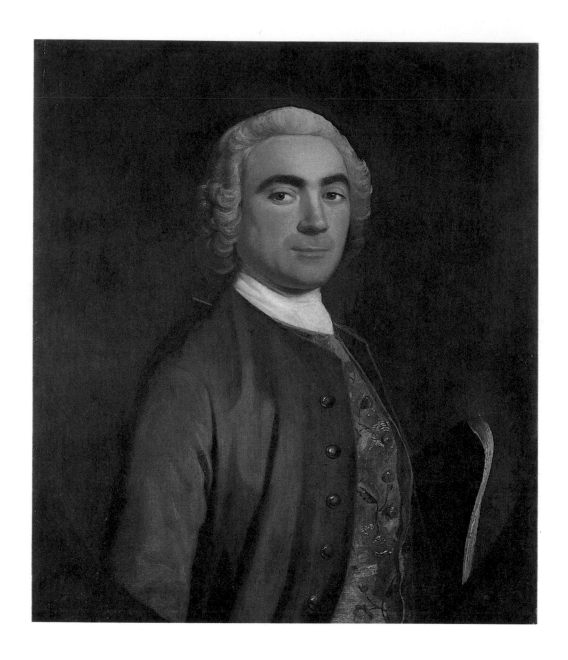

Allan Ramsay
Edinburgh 1713-Dover 1784
Portrait of a Man
London, Tate Gallery

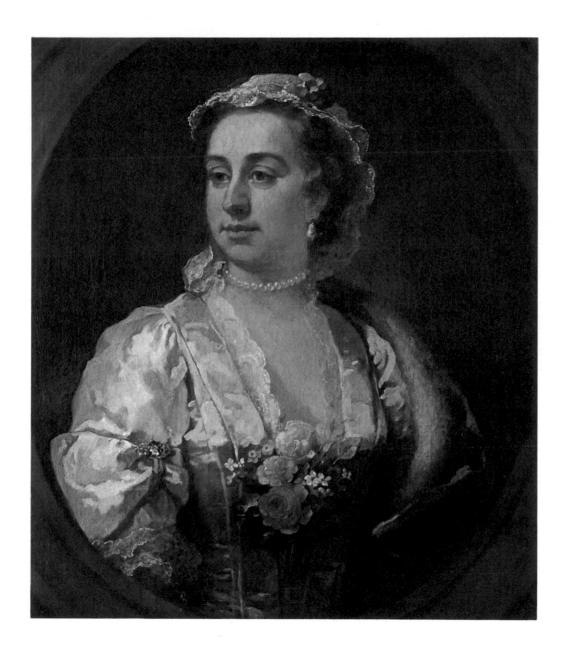

William Hogarth
Portrait of Viscountess de la Valette
Oil on canvas 2′6″ × 2′1″
Geneva, Museum of Art and History

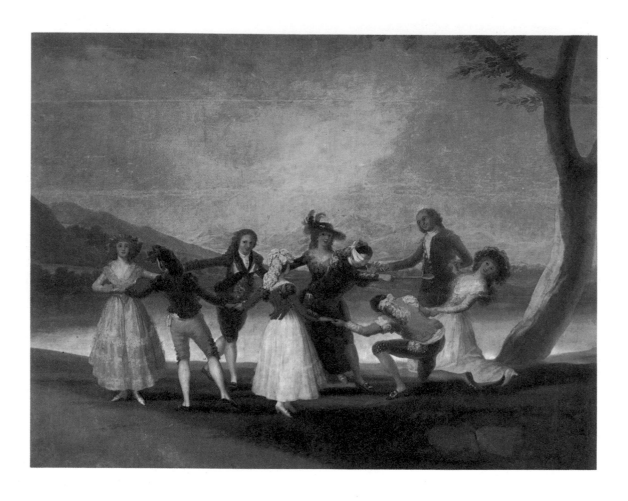

Francisco de Goya
Blind-man's Buff
Cartoon for Tapestry
Oil on canvas 8′10″ × 11′6″
Madrid, Prado

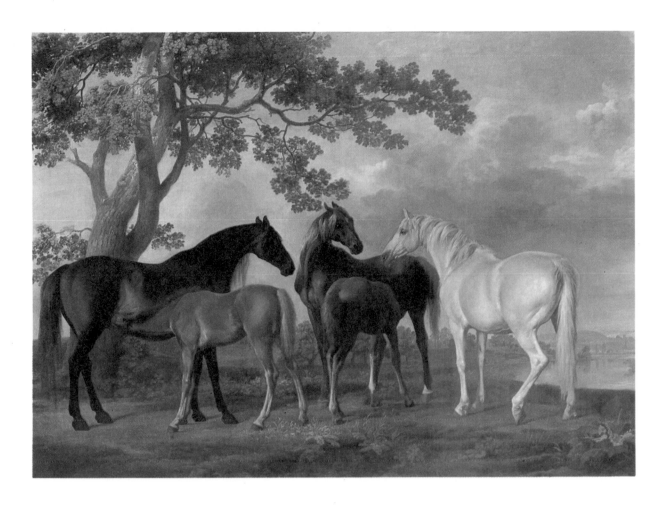

George Stubbs
Liverpool 1724-London 1806
Mares and Foals in a Landscape
London, Tate Gallery

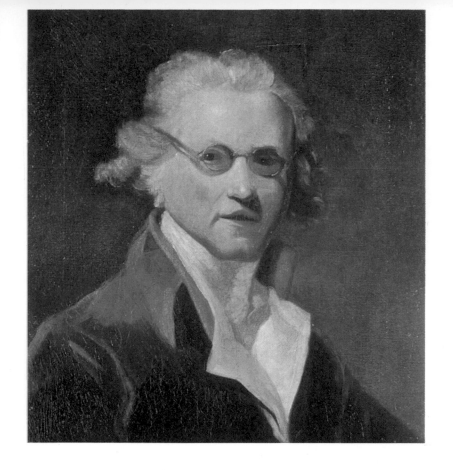

Sir Joshua Reynolds
Self-portrait
Oil on canvas 2'0" × 1'7"
Lugano, Thyssen Collection

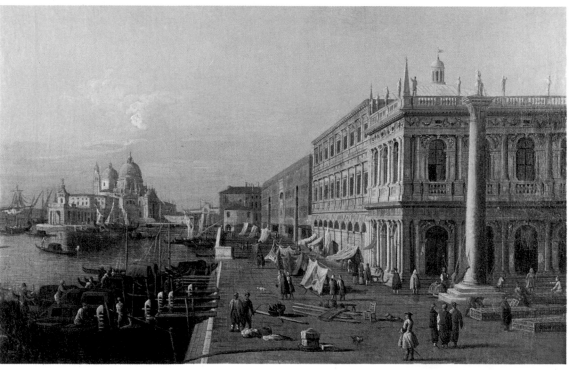

Bernardo Bellotto, called Canaletto
Venice 1724-Warsaw 1780
Entrance to the Grand Canal in Venice
Oil on canvas 1'10" × 2'7"
Private Collection

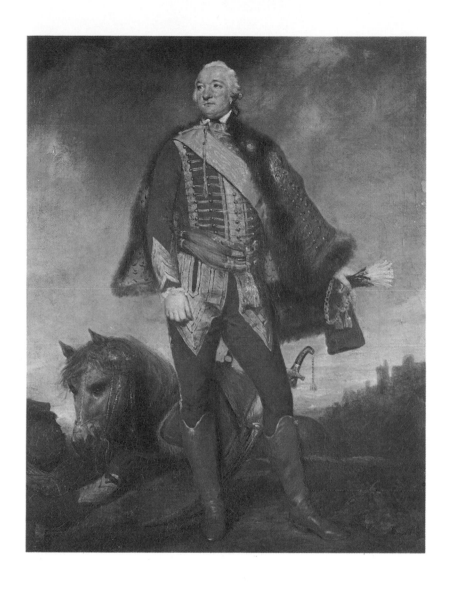

Sir Joshua Reynolds
Portrait of Louis-Philippe-Joseph d'Orléans
Chantilly, Condé Museum

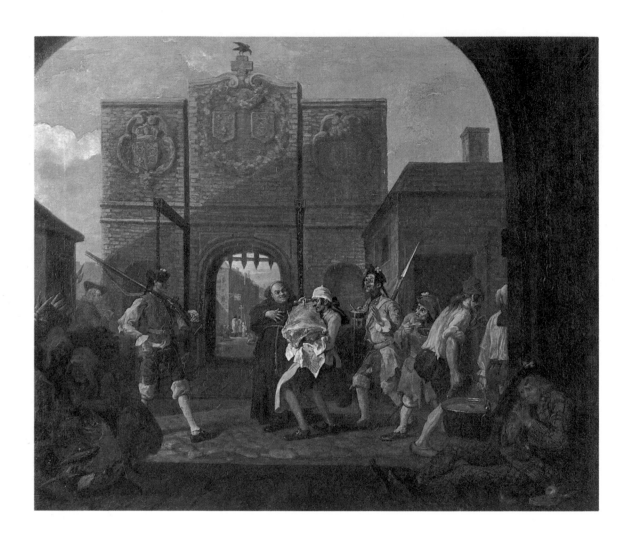

William Hogarth
London 1697-1764
Calais Gate
London, National Gallery

Glossary of 18th Century Art

Aberli, Johann Ludwig (1725-86)

Swiss artist, painter and engraver. Born at Winterthur, died in Berne. Aberli, a pupil of Felix Meyer, is known for his Swiss landscapes executed in a style that made him the originator of the mountain landscape, often imitated since. The Berne museum has several of this artist's works.

Algarotti, François (1712-64)

Italian critic and poet, born in Venice, died in Pisa. Was a friend of Voltaire, who called him "The Swan of Padua". His work on dissemination of knowledge among the masses, *Il Newtonianismo per le Dame* (Newtonianism for Women), was a great success in the period. He also wrote the interesting *Letters on Painting*.

Asam (The Brothers)
Cosmas Damian (1686-1739)
Egid Quirin (1692-1750)

The Asam brothers were the first architects of the Rococo style churches of Bavaria. From 1712 to 1714 they studied in Rome where Egid Quirin was influenced by Bernin. He began working in Germany in 1720. Their talents were divided particularly between the fresco (Cosmas Damian) and sculpture (Egid Quirin). Notable among their work is the church at Weltenburg with a statue of *St George slaying the Dragon* and a very beautiful bust of *Cosmas as a Cherub* by his brother. Osterhofen and Straubing were among their later masterpieces. In Munich, alongside the church of Saint-John Nepomuk which they built, stands the celebrated "House of the Asam Brothers"

(1733-46), one of the major monuments of German Rococo where the decoration of the façade is treated like that of the interior of a church or a castle.

Aved (called The Batavian) (1702-66)

Aved was born at Douai, and after the death of his father served his first apprenticeship in the studio of François Boitard in Amsterdam. In 1721 he went to Paris and took lessons from the portrait painter Belle; he was joined by his contemporaries Carle Van Loo and Chardin. In 1734 he entered the Academy where he had exhibited portraits of Jean-François de Troy and de Caze. He showed works at the Salons of 1737 to 1759. In 1744 he became counsellor to the Academy and in 1764 became a Pensioner. His *Portrait of Louis XV* in 1744 won him the title of painter to the King, but he made his reputation with *Portrait of Mehemed Effendi* (Versailles Museum), which he exhibited at the Salon. Aved died in Paris in 1766.

Bellotto, Bernardo (called Canaletto) (1724-80)

Italian painter and engraver, born in Venice, died in Warsaw. He was nephew and pupil of Antonio Canal, also called Canaletto. It is very difficult to distinguish the works of these two Venetian portraitists. They have been confused to the point where both are known by the same name, Canaletto. From the age of fifteen Bellotto was a pupil in his uncle's studio, where he met Pietro Longhi and Francesco Guardi. Bellotto's adventurous spirit took him in his early twenties to

Verona, Pavia, Turin and Milan. He spent several years in England under the patronage of Horace Walpole and then installed himself in Saxony in 1747. He became King's painter to August III in Dresden. King Stanislas Poniatowski took him to Warsaw with the title of court painter and Bellotto spent the last years of his life there. The Dresden Museum still has a great many of his views of the city.

Benefial, Marco (1684-1764)

Italian painter, born and died in Rome. He was a pupil of Bonaventura Lamberti in 1698. In 1718 Pope Clement XI commissioned him to carry out decorative work in the churches of Saint-John Lateran and Saint-Peter's in Rome, which in 1746 won him admission to the St Luke Academy. Raphael Mengs was his pupil.

Blake, William (1757-1827)

Blake was born in London; little is known of his ordinary life and the preferred stories were those which attributed to this visionary poet and painter a suggestion of madness. (The originality of his nature earned him the soubriquet of " Mad Blake ".) The solicitude of a father of modest origins (he was a hosier) and his exceptional gifts in poetry and drawing won him an apprenticeship at the age of fourteen with an engraver. He lived off his art, experiencing real difficulties, discouraging buyers with the fantastic nature of his compositions. His wife, Catherine Bouchez, helped him until she died, sustaining him in a difficult livelihood. She is everywhere in his work, even among his long figures of women.

Blake invented a colour engraving process which he used for the illustration of his poems. He also illustrated Young's *Nights* in 1797, the *Divine Comedy*, etc.

His drawings and paintings are conserved in the National Gallery in London. Among his lyrical works must be listed: *Songs of Innocence* (1789) and *Songs of Experience* (1794); among his fantasy narratives: *The Book of Thel* (1789), *The Marriage of Heaven and Hell* (1790) and *Europe* (1794).

Boucher, François (1703-70)

François Boucher was born and died in Paris. His father designed patterns and made prints for embroidery. François at first studied under his father, then under Lemoine, whose style he succeeded in imitating perfectly. At 17 he finished his first picture, *Judgement of Susanna*, which left Lemoine overwhelmed at the early development of his pupil. Three months later Boucher was a pupil of the engraver Cars. There again he showed such ability that Julienne commissioned him to reproduce the works of Watteau for an average £24 a day. In 1723 his *Evilmerodach délivrant Joachim* won him the first prize at the Academy. His works, as the custom of the day permitted, were hung in the Place Dauphine along the route of the Corpus Christi procession. They were noticed and from then on Boucher was known. He realised his dream of perfecting his art in Italy and left for Rome with Carle Van Loo. During this stay, from 1727 to 1731, he painted religious or historical subjects. But it was *Venus commandant des Armes à Vulcain pour Enée* that established Boucher as a painter of elegant mythology. About the same time he interrupted his painting to illustrate Molière and La Fontaine. In 1734 he was received into the Academy where he had presented *Rinaldo and Armida*. In April 1733 he married Marie-Jeanne Buzot, a pretty Parisienne who became his favourite model. From this period onwards the art of Boucher is

extraordinarily varied: he decorated interiors, furniture, ceramics and so on. From 1744 to 1748, as chief decorator to the Royal Academy of Music, he painted canvases generally on bucolic subjects. From 1740 he showed his canvases at the Salons; in 1745 he exhibited and successfully sold his drawings and red chalks. In 1752 the patronage of the Marquis de Marigny secured him a pension and lodgings at the Louvre. Three years later he succeeded Oudry as deputy inspector of the Gobelins Manufactory; in 1765 he was appointed principal painter to the King. From this moment, however, his renown, which had been established before he won this coveted title (the protection of Madame de Pompadour, in particular, had secured him a pension and a great number of official commissions) began a noticeable decline. His nomination as principal painter in fact was accompanied by a change in art fashion. From then on Greuze had all the esteem of Diderot, who flayed Boucher in his *Salons*. Boucher resigned himself to a changing world. The deaths of Deshays in 1765 and Baudouin in 1769 were hard blows; it was no longer just his glory that was melting away but something more personal, a family and pupils.

Canal, Antonio (called Canaletto) (1697-1768)

Canaletto was born in Venice where his father, theatre decorator Bernardo Canal, gave him his first instruction. In 1719 he went to study in Rome, where he appears to have known Giovanni Battista Panini. After two years he returned to Venice where Carlevaris and Ricci were then the masters of landscape painting. Despite such competition he quickly succeeded in making his own talent felt and rapidly became acknowledged as the premier landscape painter of Venice. At the same time his contemporaries Tiepolo and Longhi were stepping into fame, one as a fresco painter and the other as a painter of everyday patrician life. In 1741 Canaletto became involved in dealings with the British consul, J. Smith, and, receiving virtually no profit from Smith's sale of his engravings in England, went to London himself in 1746 and remained there for some time. He was in Munich about 1748 and summoned his nephew Bernardo Bellotto there. Then about 1751 he was back in London. In 1756 he returned to Venice and stayed there until he died. He became a member of the Academy in 1763. Canaletto canvases are to be found in all the European museums.

Chardin, Jean-Baptiste-Siméon (1699-1779)

Chardin was born 29 November 1699 in the Rue de Seine in Paris. His father, a cabinet-maker, entered him at the age of nineteen into the studio of the painter Pierre-Jacques Cazes. His sojourn with Cazes had a certain importance for Chardin for it was there that he developed a taste for Dutch and Flemish painting. He became later the pupil of Nicolas Coypel. In 1728, employed as helper by Jean-Baptiste Van Loo to restore the frescoes of Primaticcio at Fontainebleau, Chardin painted a signboard for a surgeon. When it was put in place it was noticed and the attention of the Academy was drawn to the artist. In the same year he hung several paintings in the Place Dauphine, among them the famous *Raie Ouverte*. Largillière noticed the painting. He met the artist and advised him to present himself to the Academy. Chardin was accepted in 1728 as " painter of fruits and animals ". Three years later he was married, at the church of Saint-Sulpice, to Marguerite Saintard. They had a son, Pierre-Jean, who was destined to become a mediocre painter and take his own life in Venice. Chardin's

wife died in 1735. For some time Chardin continued to hang his work in the Place Dauphine. In August 1738 he exhibited for the first time at the Salon, where he presented still-lifes and interior scenes. Critics of the period found in his work an exactitude in painting objects (Diderot even had a good page on the "natural" quality of a misty film around a plate of fruit). But his interior scenes made less impression at the time; this kind of painting then was often classed as "bad taste". In 1744 Chardin married again, to Françoise-Marguerite Fouget, a wealthy but avaricious woman who seemed to be the epitome of all the bourgeois virtues. While his renown grew, Chardin continued painting in the same painstaking way, never working on more than one canvas at a time and ignorant of riches that painting so intimate and subdued as his could not bring him. In spite of accommodation he received at the Louvre in 1757 he continued to associate with unassuming people. Towards the end of his life in 1770, his sight, now weaker, prevented him from using oil colours any longer: he set himself to paint with pastels. A portrait of his wife and three self-portraits are of this period. In 1774 he resigned from the post of treasurer of the Academy.

Crome, John (1768-1821)

English painter and engraver called "Old Crome", born and died in Norwich. From a modest family, Crome had difficulties at the beginning of his career. He set up in his native city a school of painting which was successful enough to allow him to live by his art. From 1805 he organised exhibitions of the Norwich Society of Artists, which became an important landscape school. From 1806 onwards he exhibited regularly at the Royal Academy. In 1814 he travelled through Belgium and France. He carried out a series of engrav-

ings which were gathered together after his death under the title of "Picturesque Norfolk scenery".

David, Jacques-Louis (1748-1825)

French painter, born in Paris, died in Brussels. In 1769 he became the pupil of Vien and two years later won the second prize in Rome. He took the first prize in 1774 with *The Loves of Antiochus and Stratonic*. He went to Rome with Vien and stayed there until 1780. In 1783 he was made a member of the Academy. He became acquainted with Napoleon who, while he reigned as Emperor, named David as principal painter. But the post of official painter caused him to lose a great deal of his personality. On the fall of the Empire he exiled himself to Belgium and settled in Brussels. David's painting is cold and the movement of the revival of antiquity which he created is of little interest. But it was he who began to react against the mannered art of the 18th century; he exerted a strong influence during the first half of the 19th century.

Doyen, Gabriel-François (1726-1806)

French painter, born in Paris, died in St Petersburg. His father was upholsterer to the King. A pupil of Carle Van Loo, Doyen won the Rome prize in 1746 and stayed in Italy for nine years. He was admitted to the Academy in 1759. He worked principally as a decorator: in 1767 he painted pictures for the church of Saint-Roch and for the vault of Saint-Gregory's Chapel at the Invalides. In 1777 he was appointed chief painter for the Count of Provence and the Count d'Artois. In 1789 he left for Russia at the invitation of Catherine II. There he decorated royal palaces until the time of Paul I, who entrusted to him the decoration of the Hermitage Palace. Doyen was

one of the last representatives of the 18th-century school.

Drouais, François-Hubert (1727-75)

French painter, born and died in Paris. Son of a miniaturist and pastel painter, Hubert Drouais, who was known for his *Portrait de Madame de Pompadour*, François-Hubert took lessons from his father, from Carle Van Loo, Natoire and Boucher. A protégé of Madame du Barry, he was a portrait painter of repute, particularly of children's portraits, during the reign of Louis XV. Accepted by the Academy in 1755, court painter in 1756, he was in turn received into the Academy, appointed King's painter and to other members of the royal family. He took part in exhibitions at the Louvre from 1755 to 1775. His son Jean-Germain, born in 1763, who died at the age of twenty-five, was one of the first pupils of David.

Duplessis, Joseph (1725-1802)

Portrait painter, born at Carpentras, died at Versailles. His father, Joseph-Guillaume Duplessis le Vieux, who had given up his profession of surgeon, was his first teacher. Afterwards he studied under Imberg and Subleyras. Approved by the Academy in 1769, he was admitted in 1774 and became adviser to the Academy in 1780; appointed director of the Versailles Gallery, he became administrator of the museum that was installed there in 1794. After becoming court painter, he made portraits of Louis XVI and most of the personalities of the period.

Fragonard, Jean-Honoré (1732-1806)

Fragonard was born on 5 January 1732 into a modest family in Grasse. At the age of six he went with his parents to Paris, where his father was to work. While very young he worked as a clerk in a lawyer's office. Boucher, to whom he was offered as a pupil, sent him to Chardin but accepted Fragonard himself six months later. In his master's studio, subjected to the sole discipline of work, Fragonard studied anatomy, perspective and the technique of light and shade on engravings by Rembrandt, Rubens and Tiepolo. In 1752 Boucher entered his pupil for the Rome competition. Fragonard took the first prize with *Jéroboam sacrifiant aux Idoles* (Jeroboam sacrificing to the Idols). In 1753 he entered the royal school for aided pupils as a boarder. There he painted *Psyché*, which was shown to the King in March 1753. During the same period the Brotherhood of the Holy Sacrament in Grasse commissioned from him a holy picture: *Jesus washing the Feet of the Disciples*. In 1756 the Marquis de Marigny sent him to the Villa Medici. Little is known of the first part of his stay there, but in 1758 a letter from Natoire, then director of the French Academy in Rome, gave de Marigny an account of Fragonard's talent. In Italy in 1759 he met the Abbé St Non, of whom he painted a number of portraits. This art lover, himself an engraver, took Fragonard under his patronage and thus allowed the artist to prolong his stay in Italy. In the summer of 1760 Fragonard lived at the Villa d'Este with the abbé and Hubert Robert. Attributed to this period is Fragonard's *Tall Cypresses of the Villa d'Este*. After a trip to Naples Fragonard returned to France in May 1761 with the abbé. In March 1765, aspiring to the title of King's painter, he submitted *Coresus sacrificing Himself to Save Callirhoe*; it was accepted. The canvas, bought by de Marigny, was sent to the Gobelins to be executed in tapestry. Fragonard obtained lodgings in the Louvre and, for a reception piece, was instructed to execute a ceiling for the Apollo Gallery. Then, too busy with commissions that followed the

success of his *Pastorales*, he renounced the project and consequently was never admitted to the Academy. In 1767 a painting inspired by the *Journal de Collé* won him the reputation of a libertine painter. Commissions flowed in, particularly from the Marquis de St Julien. In 1769 he married Marie-Anne Gerard, aged seventeen. In the same year he undertook important decoration work for Madame du Barry. Rejected, the work was returned to him with £18,000 as compensation. In 1773, on the recommendation of the Abbé St Non, Farmer-General Bergeret de Grancourt joined the Fragonard family in a trip across Italy to Vienna and Dresden. The two men did not get on together and Fragonard had to bring a lawsuit to recover from Bergeret the sketches he had made during the trip. Back in Paris he painted *Fête de Saint-Cloud* (Festival of St Cloud) and worked for the actress Adeline Colombe. It was then a period of full prosperity, but before long the Revolution took both his fame and his fortune. In 1789 the Fragonard family left for Grasse, where the painter sold to one of his relatives for a very low price the canvases which he regarded as compromising. Returning to Paris he sent his son Evariste to study under David, from whom Fragonard received various official commissions. These he lost a year before his death. His work sold badly but Fragonard appeared resigned to this mediocrity. He died on 22 August 1806 from congestion.

Gainsborough, Thomas (1727-88)

Gainsborough was born into a large family in Sudbury, Suffolk, where his father was a tailor. He was remembered as a mediocre pupil, caring little for his studies. About 1742 he went to London and became the pupil of Gravelot, working on the restoration of paintings of the Dutch school. Later he entered St Martin's Academy. When he had obtained enough knowledge, Gainsborough returned to Sudbury and set himself up as painter of portraits and landscapes. At nineteen he married Margaret Burr and with the money she provided he was able to paint from then on without financial worry. In 1746 he went to live in Ipswich, then in 1758 at Bath, where he remained until 1774. This was the period of his portraits. The success of his work led him to increase his prices. In the same period he painted landscapes which were less appreciated. In 1766 he became a member of the Society of Artists and exhibited in London. In 1768 he was one of the founders of the Royal Academy. The number of his admirers in London never ceased to grow, and in 1774 he decided to settle in London, where he was undeniably a success. During this period there were numerous clashes between Gainsborough and Reynolds, neither of whom would concede to the other the title of the greatest portrait painter. In 1783 Gainsborough ceased exhibiting at the Academy after an incident with the hanging committee, which had refused to hang his *Portrait of the Royal Family* at the height demanded by the painter; but he did exhibit once more before his death. In 1787 he developed cancer and Reynolds came to see his old rival and be reconciled. Gainsborough died the following year.

Goya y Lucientes (Francisco José de) (1746-1828)

Goya was born on 31 March 1746, near Saragosa. In 1760 he went to the Saragosa school to study painting and in 1763 left for Madrid. He once said his teachers were "Rembrandt, Velasquez and Nature" but he studied under Francisco Bayeu, painter to the King with Mengs and Tiepolo. In 1766 he went to Italy and

the following year took the second prize for painting at the Parma Academy. He left Italy in 1771. Returning to Saragosa, he did his first important work, decorating the chancel of the church of Our Lady of the Pillar. In 1775 he undertook, in Madrid, a series of cartoons for the royal tapestry factory at Santa Barbara. He worked under the direction of Raphael Mengs with his instructor, Francisco Bayeu. In 1775 he married Bayeu's daughter, who bore him twenty children, almost all of them dying at a very young age. In 1780 he was received into the San Fernando Academy with his *Crucifixion*. For some time he had been presented at court and had become a celebrity; he painted the portraits of all the important people, including that of the King. In 1785 he was appointed deputy-director of the San Fernando Academy and from then on lived an opulent life. He bought a house at San Isidoro where he received friends. In 1788 Charles III died. His heir, Charles IV, named Goya painter of the King's chamber. But at the same time Goya fell ill and remained incurably deaf. His liaison with the Duchess of Alba ended in 1802 when the Duchess was mysteriously poisoned. The Majas date from the period of this liaison. In 1800 Goya painted a collective portrait of the royal family. In 1808, horrified by the Napoleonic invasion, he painted *The Outbreak of May 3* and *May 3, 1808*. Later he made the engraving *Disasters of War*. About 1824 he fell out of favour with Ferdinand VII and went to Bordeaux. At the age of eighty he made a trip to Madrid, but returned to Bordeaux and died two years later.

Gravelot (known as Hubert-François Bourguignon d'Anville) (1699-1773)

French painter and engraver, born and died in Paris. Gravelot was best known for the books he illustrated (Boccaccio, Racine, Corneille, Marmontel, Ovid, etc.)

Studied art in Paris. In 1733 Claude du Bosc invited him to London to help with engraving. It was at this time that Gravelot published his *Treatise on Perspective*. Through the drawing school he opened in the Strand, Gravelot was able to exercise a certain influence over the English school. Notable among his pupils was Gainsborough. Gravelot was also one of the first caricaturists in England. In 1754 he settled in Paris where he made a great reputation as an illustrator; among his works are the engravings for Rousseau's *Nouvelle Héloïse*.

Greuze, Jean-Baptiste (1725-1805)

Greuze was born in Tournus, where his father was a slater. In his middle twenties he went to Lyons to learn painting in the studio of the painter Grandon. About 1750 he was studying under Natoire in Paris. Very rapidly one of his paintings, *Father of the Family explaining the Bible to his Children*, was noticed and made his name. The Academy accepted him in June 1755; without delay Greuze exhibited at the Salon stylised scenes which, apart from some portraits, were to constitute the whole of his work. From September 1755 to April 1757 he travelled in Italy but this did not seem to have any effect on his work. Returning to Paris he exhibited in 1761 *Accordée de Village* (The Village Betrothed), which put the seal on his success; *Paix en Ménage* (Peace in the Household) and the *Paralytique soigné par ses Enfants* (Paralytic tended by his Children) were new successes. About this time Diderot noted in his *Salons* his preference for Greuze at the expense of Boucher. But then Greuze made an unfortunate error: trying to enter the Academy as an historical painter, he presented a canvas *L'Empereur Sévère reprochant à son Fils d'avoir voulu l'assassiner* (Emperor Severus reproaching Caracalla). The Academy committee gratuitously snubbed him on

this and classified him as a genre painter on the basis of his previous work. From that moment Greuze refused to exhibit at the Salon and never again set foot inside the Academy. At the same time the popularity of his work began to dwindle. Stricken by all sorts of worries, he separated from his wife, who had almost ruined him, in 1785. The Revolution, which he welcomed enthusiastically, did nothing to restore him to favour. He exhibited at the Salon in 1800 and 1802 without marked success: his style had definitely ceased to please. He died on 21 March 1805, and by a strange quirk of fate left unfinished a *Portrait of the Emperor*, which his daughter was to complete.

Hogarth, William (1697-1764)

English painter, born and died in London. At fifteen he became an apprentice. At first his teacher was the engraver Ellis Gamble; later he studied under James Thornhill, whose daughter he married. His first great work, a series of six engravings called *A Harlot's Progress*, appeared in 1732. It was followed three years later by *A Rake's Progress*. Ten years later came his masterpiece, *Marriage à la Mode*. From then on his works became more and more caricatured. In April 1764, shortly before he died, he painted a curious picture in which his own face appears behind the features of an old bearded man. In 1753 he published his celebrated *Analysis of Beauty*. A self-portrait with his dog appears in the National Gallery in London.

Huysum (Jan Van) (1682-1749)

Dutch painter, born and died in Amsterdam. Son of Juste van Huysum, a floral painter, he specialised in painting flowers, still-life and landscapes. He painted sculpted vases, marble consoles and bas-reliefs to emphasise the quality of his bouquets of flowers. His work was bought by the Kings of Poland and Prussia and the Duke of Orleans. In England his fame was spread by Horace Walpole.

Jouvenet, Jean (1644-1717)

French painter, born in Rouen, died in Paris, studied under his father, Laurent Jouvenet. From 1661 he studied at the Royal Academy in Paris and was admitted to the Academy in 1675. He was a great success, and after the death of Mignard and Le Brun became the head of the French school. He carried out the decoration of the Rennes Parliament in 1695. Because of a stroke he lost the use of his right hand towards the end of his life, but quickly trained himself to use the left hand.

Kauffmann, Angelica Catharina Maria Anna (1740-1807)

Born in Coire, Switzerland, died in Rome. Because she showed very great promise in drawing at a very early age, her father put her into boy's clothing so that she could attend classes at the Academy. She studied in Florence, Rome, Venice, had a great success in Italy and then at court in London where, in 1768, she became one of the original members of the Royal Academy. She painted a portrait of her great friend Sir Joshua Reynolds, later married the Venetian painter Antonio Zucchi and went to live in Rome. Her work was graceful and included portraits, mythology and allegories.

Kneller, Gottfried (1646-1723)

Portrait painter, of German origin, born in Lubeck, died in London. He succeeded

Van Dyck as official portrait painter to the court in London. He first studied under the Dutch painter Ferdinand Bol, where he assimilated Rembrandt's technique. In 1672 he went to Rome as the pupil of Carlo Maratta and Bernini. After a stay of two years in Italy he returned to Germany, then went to London: here his success was considerable. He collaborated at the court with Peter Lely. A great number of his portraits are to be found in European museums.

Kucharski, Alexander (1741-1819)

Polish painter, born in Warsaw, died in Paris. He studied in Italy and in Paris, where he painted a portrait of Marie Antoinette in 1780. Twice he found himself working in the Temple prison: he painted a new portrait of Marie Antoinette while she was being detained there.

Lagrenée, Louis-Jean-François (1725-1805)

French painter, born and died in Paris. He was a pupil of Carle Van Loo, won the Rome prize in 1749 and was accepted by the Academy in 1755. In 1760 he was appointed director of the Fine Arts Academy at St Petersburg, but returned to Paris three years later. In 1781 he became director of the Rome school. On leaving this school he received a pension from the King and an apartment at the Louvre.

Lancret, Nicolas (1690-1743)

French painter, born and died in Paris, son of a coachman. He first learned engraving as the pupil of Pierre Dulin. In 1702 he was expelled from an Academy course and withdrew from the competition for the Rome prize after an early setback. Studying under Gillot, he began

to imitate Watteau. On Watteau's advice he applied himself to painting landscapes, about 1717. He was admitted to the Academy in 1719 as painter of *fêtes galantes*, the type in which he specialised. He received many commissions from the great European collectors, including Louis XV, Frederick II and the Prince. He was named adviser to the Academy in 1735. He painted many decorative pieces for Versailles, La Muette and Fontainebleau and a series of paintings inspired by La Fontaine's *Fables*.

Largillière (Nicolas de) (1656-1746)

French painter, born and died in Paris. His parents went to live in Antwerp three years after his birth and it was there that he served his apprenticeship. Admitted as master of the Guild in 1672. In 1674 he worked in London under the direction of Peter Lely. Persecution of the Catholics brought him to Paris in 1678 where, as a protégé of Le Brun, he built up a considerable reputation. In 1685 he went to London to paint a portrait of King James II and the Queen. In 1686 he was admitted as a member of the Royal Academy in Paris (*Portrait of Le Brun*) and was named a director in 1728. He painted a great number of portraits of women, at which he was more gifted than his friend Hyacinthe Rigaud, and to whom, in return, he sent his male clients.

La Tour (Maurice Quentin de) (1704-88)

French painter, born and died at St Quentin. His father wanted him to be an engineer but La Tour rapidly proved his own talent. In 1722, after being refused several times, he succeeded in working with Spoede and Dupoch in Paris. In 1724 he was at Cambrai, where a diplomatic congress was being held. The British Ambassador offered him a place in Lon-

don and La Tour remained there for two years. On his return he wanted to take advantage of the pro-British feeling of his countrymen in passing himself off as an English painter, but instead, on the advice of a contemporary, retired for two years to perfect his drawing and read scientific and literary works. In 1737 he was accepted by the Academy on presentation of two pastel portraits. He exhibited at the Salon from 1739 until 1765. His work fetched high prices at this time. In 1745 he exhibited at the Salon a *Portrait of the King and Dauphin*; the same year he received permission to live at the Louvre. He was admitted to the Academy in 1746 with a portrait of his master, J.Restout. In 1751 he was named adviser to the Academy. In 1753 his *Portrait of Queen Marie Leczinska* was exhibited at Versailles; the vogue of his work grew incessantly. *Portrait of Madame de Pompadour*, regarded as his masterpiece, was painted in 1755. In 1766 he travelled in Holland. Towards the end of his life La Tour sank into a delirium and his brother took him back to St Quentin, where his family had him certified. He died on the night of 16-17 February 1788. The St Quentin Museum has about eighty pastels, found in his studio at the time of his death.

Lawrence (Sir Thomas) (1769-1830)

English portrait painter, died in London. In 1787 he entered the Royal Academy in London as a pupil. Lawrence rapidly distinguished himself as a portrait painter and replaced Reynolds as an ordinary painter to the King in 1792. Made a member of the Royal Academy in 1794, he pursued a brilliant career as a portraitist. In 1814 and 1815 he painted the portraits of the Prince Regent and leading French personalities who were in London. In 1818 he went to Aix-la-Chapelle. Vienna and Rome and brought back por-

traits for the royal collection. He was made President of the Royal Academy and made a portrait of Charles X in 1825. His works remain in Dublin, London museums and in the Louvre.

Le Lorrain, Louis-Joseph (1715-59)

French painter and engraver, born in Paris, died in St Petersburg. Was the pupil of Dumont le Romain. Won the first prize for painting in 1739, admitted as Academician in 1756. Two years later he was director of the Academy of Fine Arts at St Petersburg. In 1753, 1755 and 1757 he exhibited religious, mythological and decorative subjects at the Salon. He illustrated Le Fontaine's *Fables* and *Orlando Furioso*.

Lemoine, François (1688-1737)

French historical and genre painter, born and died in Paris. Won the Academy grand prize in 1711 and was admitted in 1718. In 1723 he travelled in Italy. Lemoine painted various pictures for the Chateau of Versailles and Saint-Sulpice Church in Paris (1729-31). In 1733 he was appointed professor at the Academy. From this date he began decorating the Hercules Salon at Versailles which gained him the title of King's principal painter in 1736. He took his own life the following year.

Levitski, Dimitri Gregoriovitch (1735-1822)

Russian portrait painter, born in Kiev, died in St Petersburg. He enjoyed a considerable reputation and painted portraits of the Imperial family and leading Russian personalities. The Leningrad and Moscow museums have a number of these works.

Liotard, Jean-Etienne (1702-89)

Swiss painter, of French origin, born in Geneva. Went to Paris in 1723 where he worked for several princely families and for ecclesiastical circles. Of an adventurous nature, he undertook a number of journeys, to Rome (1736), to Constantinople, where he stayed five years, and to Moldavia. He was a great success in Vienna where, because of his Moldavian-style beard, he was called "The Turkish Painter"; from this period dates his greatest work, *The Chocolate Seller*, which is in the Dresden Museum. After Venice, Darmstadt and Lyons he went to Paris where his success was as great as in Vienna. Before settling in Geneva in 1758 he stayed in England, Holland, again in France and went several times to Vienna. In his latter days he produced a technical work, *Treatise on the Principles and Rules of Painting*. Liotard left for posterity pastels, miniatures, portraits and paintings on enamel.

Longhi, Alessandro (1733-1813)

Italian painter and engraver, born and died in Venice. Taking advantage of the popularity of his brother Pietro Longhi, Alessandro was able to paint portraits of Venetian society. He was a member and professor of the Academy. He also produced a *Life of Modern Venetian Artists* with portraits engraved by himself, which contained valuable information on Venetian painting of the time.

Longhi, Pietro (1702-85)

Venetian genre painter, pupil of Balestra and particularly of G. M. Crespi. Passed his life in his native city, with honours heaped on him and a degree of wealth. He was the painter of the well-off middle class of Venice, whose private and public lives he put on canvas. The greater part of his works are in Venice in the Correr Museum, the Academy, the Palazzi Grassi and Albrizzi.

Menageot, François-Guillaume (1744-1816)

French painter, born in London, died in Paris. Worked with Deshays and Boucher. In 1765 he took the second, and in 1766 the first, prize in Rome. In 1780 he was admitted to the Academy, in 1787 appointed director of the French school in Rome, in 1790 professor at the Ecole des Beaux-Arts and in 1809 a member of the Institute. He worked in several Paris churches, notably Saint-Nicholas du Chardonnet and Saint-Eustache, as well as the church at Neuilly and Saint-Peter's at Douai.

Mengs, Anton Raphael (1728-79)

German painter and writer, born at Aussig, Bohemia, died in Rome. Studied painting in Dresden and Rome, where he became a court painter in 1745. He worked on the decoration of the church of Saint-John in Rome and painted numerous portraits of princes. In 1761 he became principal painter to King Charles III of Spain and worked with Tiepolo on frescoes for the royal palace. He returned to Italy in 1769 and settled in Rome. From 1773 to 1777 he stayed again at the court of the King of Spain. He rose to brilliant glory during his lifetime; likened to Titian, Correge or Raphael, he imposed a veritable dictatorship on his pupils and on painters who occupied less official positions than his own.

Mercier, Philippe (1689-1760)

Genre painter and portraitist, born in Berlin of French parents, died in London.

He studied in Berlin, Venice, Florence and Rome. In 1720, after his marriage, he settled in Hanover where he made the acquaintance of the Prince of Wales. He went to London with the Prince and painted several portraits of the British royal family. His rural festival scenes, very much liked in England, were often mistaken for those of Watteau.

Natoire, Charles-Joseph (1700-77)

French painter, born at Nîmes, died at Castelgandolfo. Son of the architect and sculptor Florent Natoire, he was a pupil of Lemoine. In 1731 he won the first prize for painting with *Manné offrant un Sacrifice pour obtenir un Fils* (Manné offering a Sacrifice to obtain a Son). He studied in Rome where, at a young age, he acquired a wide reputation. Returning to Paris he exhibited at first in the Place Dauphine. In 1734 he entered the Academy and became professor there three years later. He took part in the decoration of the Hôtel de Soubise and made numerous tapestry cartoons for the royal tapestry works. In 1751 he became director of the French school in Rome. The Stockholm Museum has several of his works.

Nattier, Jean-Marc (1685-1766)

French painter, born and died in Paris, son of Marc Nattier, a portrait painter in the reign of Louis XIV. Nattier began by making drawings for engravers, including the Rubens of Luxemburg. In 1715 the Tsar summoned him to Amsterdam, where Nattier painted the portraits of the imperial family and other important members of the Russian court, and the *Battle of Poltava*. Returning to Paris, Nattier became a member of the Academy in 1718 and professor in 1752. He worked as a portrait painter, became known in the entourage of the Duke of Orleans and was appointed painter to the royal family in 1745. From 1737 to 1763 he exhibited regularly at the Salon, but died disgraced and generally forgotten.

Norblin de La Gourdaine, Jean-Pierre (1745-1830)

French historical painter and portraitist, born at Misy-sur-Yonne and died in Paris. He studied in Dresden with Giovanni Casanova. In 1771 he won the grand prize of the Dresden Academy. He founded the Warsaw Academy of Painting and became painter to King Stanislas-August at the Polish court.

Opie, John (1761-1807)

English painter and illustrator, died in London. While very young he began portrait painting, but abandoned this rapidly in favour of historical painting. He exhibited at the Royal Academy from 1782 and was made a member in 1787. In 1806 he replaced Fuseli as professor of painting. His works are to be found in London museums.

Oudry, Jean-Baptiste (1686-1755)

French painter, born in Paris, died in Beauvais. His father, painter and art dealer, taught him the rudiments of his art, then sent him to the St Luke masters' school. At the age of eighteen he was a pupil of Michel Serre, then painter to the King's galleys in Marseilles. Oudry went there with Serre and did not return to Paris for four years. Then he studied for five years under Largillière. Admitted to the St Luke Academy in 1708, he became professor there in 1717. He tried first religious painting, then portraits, then urban landscapes in 1718. The Academy classified him as historical painter. In 1722 his *Chasse au Sanglier* (Boar Hunt) won him a commission from the King of

Sweden; in 1725 he was made painter to the Beauvais factory. In 1743 he succeeded de Troy as professor at the Academy. Oudry was the most sought-after animal painter of the 18th century.

Pater, Jean-Baptiste-Joseph (1695-1736)

French painter, born at Valenciennes, died in Paris. His father was the sculptor Antoine Pater. In 1713 he studied for some time under Watteau in Paris. After a stay at Valenciennes he returned to Paris where he rapidly became the painter of middle-class society. Shortly before he died, Watteau summoned Pater to give him his last advice. In 1725 he was approved by the Academy and admitted in 1728 as a painter of *fêtes galantes*. During the latter part of his life he worked on many commissions and, overworked, died at the age of forty-one.

Procaccini, Andrea (1671-1734)

Italian painter, engraver and architect, born in Rome, died at San Ildefonso. Studied under Carlo Maratta and worked in the style of his master. A protégé of Pope Clement XI, he carried out several works in Rome churches, particularly in Saint-John Lateran. Summoned to Spain about 1720 by King Philip V, he was appointed painter of the King's chamber. He remained in Spain until he died, and was responsible for the decoration of numerous churches and palaces in that country.

Quinckhardt, Jan Maurits (1688-1772)

Dutch painter, born near Cleves, died in Amsterdam. He was a pupil of Arnold van Boonen and worked in Utrecht and Amsterdam. Quinckhardt painted portraits and mythological and allegorical subjects. The Amsterdam Rijksmuseum has a large number of his paintings.

Ramsay, Allan (1713-84)

English portraitist and essayist, born in Edinburgh, died at Dover. Studied in London and Edinburgh, then in Rome and Naples, where he was a pupil of Solimèna. In London, where he settled in 1739, he was court painter to King George III. Ramsay was a portraitist of renown.

Reynolds, Sir Joshua (1723-92)

English portrait painter, born at Plympton, Devon, died in London. From 1740 Reynolds worked as apprentice to the portraitist Thomas Hudson. In 1749 he went to Italy and spent two years in Rome to familiarise himself with the techniques of the old masters by copying their works. On his return to London in 1752 he set himself up as portrait painter. Three years later he painted a *Portrait of Commodore Keppel* which won him a claim in high society. From then on he received numerous commissions, and his paintings sold at a high price, enabling him to begin an important collection of art objects, paintings and drawings. In 1760 he founded the Society of Artists, where he exhibited. Eight years later, with a handful of artists of sufficient reputation, he founded the Royal Academy, whose statutes were to be the same as those of the Royal Academy of Paris. He was elected President of the Royal Academy and, between 1769 and 1790, composed and delivered the famous fifteen *Discourses on Art*. His last great portraits were those of *King George III* and *Queen Charlotte*, which he painted in 1779. Towards the end of his life Reynolds painted mythological or allegorical subjects.

Ricci, Sebastiano (1659-1734)

Italian painter, born at Cividal di Belluno, died in Venice. In 1674 he was a pupil of Federigo Cervelli in Venice and then, in 1682, he studied in Bologna. He enjoyed the protection of the Duke of Parma. After the latter's death in 1694, Ricci went to Florence, Modena, Parma, Milan and Bergamo, then stayed in Venice for three years. Summoned to the court of Vienna, he decorated the Schönbrunn Palace. Back in Italy he decorated palaces in Florence for the Grand Duke of Tuscany. In 1718 he was admitted to the Royal Academy in Paris and later worked in England until 1728. On his return he settled permanently in Venice, where he painted mainly easel paintings.

Robert, Hubert (1733-1808)

French painter, born and died in Paris. Made his début as a painter in 1753. The following year the Count of Stainville, the future Duke of Choiseul, was named ambassador to the Holy See and took Robert with him to Rome, entering him in the French Academy which was directed by Natoire. There he was influenced by Panini and Piranesi. At a time when the research and theories of Winckelmann were restoring antiquity to fashion, Hubert Robert became a painter of ruins and Natoire encouraged him in this. He met Fragonard, with whom he stayed at the house of the Abbé St Non in Rome, then in Naples and Paestum. In July 1765 he went back to Paris after spending eleven years in Italy. He painted from the sketches he had made in Italy. In 1766 he was approved by and admitted to the Academy. The King commanded from him an overmantel for the Château de Meudon. At the same time he exhibited at the Salon; criticism was favourable and his canvases from then on were sought after. He was received at the house of the Duke of Choiseul and the salon of Madame Geoffrin. For forty years he moved through Paris making sketches for his canvases. A suspect under the Revolution he was arrested on what the revolutionary new calendar showed as the eighth day of the second month of the year II. When freed several months later he and Fragonard were named curators of the future Central Museum of Arts.

Romney, George (1734-1802)

English painter, born at Dalton-in-Furness, died at Kendal. With Gainsborough and Reynolds, Romney formed the great trio which installed English portrait painting. Son of a cabinet-maker, Romney worked from the age of ten to twenty-one in his father's workshop. In 1755 his father had him apprenticed to the painter Edward Steele, at Kendal. Two years later he set himself up in this town as portrait painter. In 1762 he went to London and from 1763 until 1772 exhibited at the Society of Artists and the Free Society. In 1764 he went to France where he met Vernet. In 1773 he was in Italy. Two years later he returned to London where his rival Reynolds was jealous of his success. He drove himself to work very hard; tired and ill, Romney returned to his family home at Kendal in 1799 and died several years later of a cerebral haemorrhage. The National Gallery in London has a large number of his portraits.

Tiepolo, Giambattista (1696-1770)

Italian painter, born in Venice, died in Madrid. Tiepolo came from a rich family. His father, a naval captain, died in 1697. A pupil of Gregorio Lazzarini, Tiepolo also was influenced by Piazzetta and Sebastiano Ricci. In 1721 he married the sister of Francesco Guardi: she bore him several children, of whom two were paint-

ers, Gian Domenico and Lorenzo. Tiepolo worked in Venice and Venetia for twenty years. In 1733 he was in Bergamo, in 1737 near Vienna and in 1740 in Milan. From 1750 to 1753 he carried out one of his most important works, the decoration of the archbishop's palace at Wurzburg. After that he returned to Venetia and worked until 1761. King Charles III summoned him to Spain, where he went with his two sons to decorate the royal palace with frescoes. He remained in Madrid until the end of his life, embittered in his old age by rivalry with Mengs. Venetia is rich in frescoes by Tiepolo. For his works he often made sketches in oils, explaining why his canvases are often to be found. He also painted genre and left drawings and etchings.

Tocqué, Louis (1696-1772)

French portraitist, born and died in Paris. Was a pupil of Nicolas Bertin and Hyacinthe Rigaud. He was admitted to the Academy in 1734. From 1737 to 1759 he sent fifty portraits to the Academy exhibitions. In 1740 he painted the portrait of the Dauphin and of Marie Leczinska. He spent two years in Russia (1757) and in 1759 lived in Denmark. With Largillière, Tocqué was one of the favourite painters of the high society of his day. His influence on the painters of foreign countries he visited was considerable: he taught Nordic painters the secret of French elegance.

Van Loo, Carle (1705-65)

Brother of Charles-Amédée and the most famous of the Van Loo brothers. He was born in Nice of a line of painters of Dutch descent. Brought up by his father, then in the service of the Prince of Piedmont, he travelled in Italy. In 1724 he won the painter-laureate prize in Rome. He returned to Rome in 1727 with Boucher. Until 1731 he stayed in Turin where he decorated the palace of the King of Sardinia. In 1735 he was admitted to the Academy and in 1748 was placed in charge of the Academy's aided pupils. Painter to the King in 1762 he achieved a considerable success despite his legendary lack of culture and his stupidity. He worked on the Château de Bellevue, the church of Saint-Sulpice and, from 1746 to 1755, painted seven canvases for the church of Notre-Dame-des-Victoires.

Vernet, Joseph (1714-89)

French landscapist and marine painter, born in Avignon, where he studied under his father, died in Paris. At Aix he began a career as decorator and painter of seascapes. He went to Italy in 1734 aided by the Marquis de Caumont. In 1743 he was admitted to the St Luke Academy in Rome and in 1746 was approved by the Academy in Paris. From 1745 to 1750 his *Scenes of Roman Life* were highly successful. Between 1750 and 1753 he stayed in Marseilles and painted shipwrecks. At this time he received a commission for fourteen paintings on the ports of France through the Marquis of Marigny, Director-General of Fine Arts and brother of Madame de Pompadour. In 1753 he settled permanently in Paris and in 1766 was named adviser to the Academy.

Vigée-Lebrun, Elisabeth (1755-1842)

French painter, born and died in Paris. She was sent to a convent at a very young age, but her father withdrew her and taught her the use of pastels. In 1774 she was approved by the St Luke Academy and rapidly acquired a good reputation as a portraitist. After her marriage to the art dealer Lebrun in 1776, she became painter to Marie-Antoinette, which allowed her to

exhibit at the Salon from 1783. The Academy admitted her the same year. When the Revolution began she left for Rome and travelled throughout Europe. She arrived in St Petersburg, where her reputation had preceded her, and stayed in the Russian court from 1795 to 1802. She returned to Paris and then spent two years in Italy. Banned during the Empire, she left for Switzerland where she met Madame de Staël. Under the Restoration she occupied an important place in the arts; Balzac, Vernet and Gavarni were among those who frequented her salon.

Watteau, Antoine (1684-1721)

French painter, born at Valenciennes, died at Nogent-sur-Marne. Watteau came from a modest but well-to-do family who did not oppose his vocation. Soon after 1699 Watteau left for Paris, without money, to try his luck there. In 1702, after a course with a painter who had no clients, he went to work as a hack for an art dealer near Notre-Dame. Earning an average £12 monthly, he worked all day at reproducing paintings. About the same time he joined Jean-Jacques Spoede, a young Antwerp artist who was studying at the Academy. At Mariette's he met a number of painters, including Claude Gillot, and lived at the latter's place from 1705 to 1708. But as Watteau soon displayed a talent superior to that of his host, the two parted. He then went to work for Claude Audran, curator of the Luxemburg Palace, and helped him with decoration of the Château de la Muette and Meudon. Audran was instrumental in allowing Watteau to see the great Rubens cycle of the Life of Marie de Medici, an important event in his training. Admitted to the Academy as a pupil, he entered for the Rome prize in 1709 but came only second. Discouraged, he decided to return to Valenciennes for some time. To pay for

the journey he sold, through his friend Spoede, a small military painting, *Return from the Campaign.* Sirois gave him 60 francs for it and ordered another which earned 200 francs. In 1710 Watteau went back to Paris with a young artist from Valenciennes, Jean-Baptiste Pater. Sirois invited Watteau to set up with him. About 1710 he painted *Island of Cythera,* a sketch for *Embarkation for the Island of Cythera.* The Academy approved him on 30 July 1712. In 1716 he was with Crozat. Among the works owned by this collector he studied the Flemish and Venetian painters. He quickly left Crozat, returned to Sirois and then set himself up in the rue Cardinal Lemoine until 1719. In August 1717 the Academy had admitted him on presentation of his *Embarkation.* Suffering from tuberculosis, he left for London in 1719 to see a doctor who had been recommended to him. He remained in London for a year. On his return to Paris he stayed for some time with Gersaint, Sirois's son-in-law, and painted for him in a single week the famous *Enseigne de Gersaint.* Before long he went to live at Nogent. Ill, Watteau seemed little by little to become detached from his work. The priest at Nogent even persuaded him to burn his paintings of nudes.

Zuccarelli, Francesco (1702-88)

Italian painter, born at Pitigliano, died in Florence. He studied in Florence and Rome. At first he painted historical scenes, then decorative landscapes. He exhibited in London, where he often stayed, from 1765, was a member of the Society of Artists, and in 1768 was one of the founders of the Royal Academy. One room of Windsor Castle is entirely furnished with his works. In 1773 Zuccarelli returned to Florence. His works may be seen in the museums of Budapest, Glasgow, London, Stuttgart and Venice.